The Sketching
& Drawing Bible

The Sketching
& Drawing Bible

An essential reference for the practising artist

Marylin Scott

Search Press

A QUARTO BOOK

Copyright © 2005 Quarto Publishing plc
This edition published in 2016 by
Search Press Ltd
Wellwood
North Farm Road
Tunbridge Wells
Kent TN2 3DR

ISBN 978-1-78221-391-8
QUAR.SDB

This book was designed and produced by
Quarto Publishing plc
The Old Brewery
6 Blundell Street
London N7 9BH

Project Editor Trisha Telep
Art Editor Tania Field
Designer Karin Skånberg
Picture Researcher Claudia Tate
Assistant Art Director Penny Cobb
Photographer Martin Norris
Art Director Moira Clinch
Publisher Paul Carslake

Manufactured in Hong Kong by Modern Age.
Printed in China by Toppan Leefung Printing Ltd.

Parts of this book have previously been
published in *The Encyclopedia of Drawing
Techniques (first edition)*, *The Encyclopedia of
Coloured Pencil Techniques* and *The Coloured
Pencil Artist's Pocket Palette*.

Contents

Introduction

The word 'drawing' often conjures up a mental image of a pencil, because this is the implement most of us begin with. But although it is an excellent medium – when graphite pencils were first invented artists would pay large sums of money for them – there are now a great many other drawing mediums, together with a host of techniques for using them. *The Drawing Bible*, a must-have for anyone who enjoys drawing, will broaden your horizons and help you to build up your skills and explore new possibilities.

This small but information-packed book is divided into three sections, with the first, 'Choosing and Using Materials', introducing you to the exciting range of drawing implements and materials from pencils, charcoal and ink pens to pastel, coloured pencil and relatively new inventions such as paint sticks and coloured inks. First, the properties of each medium are explained and then you are shown how to use them – how to build up tones in pen and pencil drawings, for example, and how to mix colours on the paper surface in pastel or coloured-pencil work.

The second section, 'Further Techniques', expands on the technical aspect of drawing and sketching by demonstrating a range of different methods in a series of clear step-by-step sequences done by professional artists. Although the book is aimed primarily at beginners,

▲ **Discover new techniques**

▶ **Learn about tools and materials**

► Look at paintings by established artists

even experienced artists may find some surprises and new ideas in this chapter – if you have never tried making a drawing from ink blots, scratching into oil pastel or combining different media in one drawing, now is your chance. If you have become over-familiar with one medium and want to experiment, try out some of the different mediums and methods for yourself, and you may find a whole new world opening up.

The third section, 'Subjects', which ranges from landscape through figures and animals to flowers and foliage, shows the drawing media and techniques in action. Here you will find an inspirational gallery of finished works by a wide range of professional artists, each of whom have established their own styles, working methods and approaches. This chapter is intended to help you learn by example; looking at other people's work is an essential part of any artist's learning curve, and you may find that it helps you towards discovering your own artistic interests, establishing a personal style and becoming confident in handling your chosen drawing medium.

▼ See how professional artists sketch subjects

Although developing skills is vitally important, what matters even more is to take pleasure in what you do, so treat the book as a springboard to launch you into the exciting world of picturemaking. Think back to the joy of drawing and painting in childhood and try to recapture some of this feeling, experimenting with different subjects and ways of interpreting them.

1
Choosing and using materials

Pencils and graphite

Pencil 'leads' are made from graphite, a soft crystalline form of carbon, which is mixed with clay and fired in a kiln. The greater the clay content the paler and harder the lead, while more graphite gives a softer, blacker mark. The lead is encased in wood, usually cedar, which is marked on the side with a number and letter classification. 'B' is for black, with more graphite; and 'H' is for hard, with more clay. The higher the number the softer or harder the pencil, so the highest number, 9B, is extremely soft.

Graphite sticks are shaped like thick pencils without the covering of wood, and are also graded: 2B is a useful average. Some sticks are lacquered for clean use, so scrape them down if you wish to make broad marks, and wrap uncoated sticks in tinfoil. Graded leads are made for some technical, or propelling, pencils. Office pencils are usually graded HB or B, and ones that make black marks can be used for drawing. Use a sharp craft knife to sharpen your pencils.

Pencils
Good-quality pencils have properly defined grades and even-grained wood casing.

Mechanical pencils
These pencils are designed for technical use, and so make a standard-width mark.

Graphite sticks
These graphite sticks are coated in lacquer. Thicker, uncoated sticks give fast sideways use.

Ungraded pencils
Soft, black, ungraded pencils have large diameters and thick leads, and are useful for broader work.

SEE ALSO

Using pencils and graphite, page 12

Erasers

The best erasers are the flexible, white plastic erasers that remove marks without abrading the paper.

Paper stumps

You can soften pencil marks with a finger, but a paper stump, or torchon, is better as fingers are always slightly greasy. Small stumps are rolled to have long points, and don't obscure your view. Larger stumps are double-ended.

Craft knife blades

The detachable blades on the large knives can be taken out for honing on a stone.

Craft knives

The blades of craft knives should always be kept sharp for sharpening and cutting.

ARTIST'S TIP

Pencil drawings are easily smudged, so if you want to make changes or add extra tone or detail at the top of a drawing, lay a clean sheet over the bottom part to rest your hand on while you work.

Using pencils and graphite

When you have tried the different grades of pencil, look at all the marks together: a soft, dark mark reduces the silvery tone of a harder grade almost to insignificance when they are placed together. These different effects can broaden your creative horizons, but mixing grades may sometimes lead to problems with light and shade. Choose the right grade of pencil for your purpose and you will need only one – because the medium is so subtle and responsive.

Your first consideration should be the size of your drawing. Large works are usually viewed from a distance, and may lack impact unless a very soft grade is used – and still may not have the drama of charcoal (see page 16), which is ideal for large drawings. Soft pencils can be used for work of any size, but hard ones should be reserved for small drawings where the paler marks will be seen from close up. Time is another factor: because pencil is a linear medium it takes a while to build up density. Hard grades are slow to work with, soft pencils are quicker, and graphite sticks even more so – especially when used on their sides.

Building up tone

Tone is built up using several methods that can be applied individually or together in the same work. Lines can be hatched or cross-hatched to achieve areas of varying density. Areas of tone can be scribbled and made darker or lighter depending on the amount of pressure applied. To blend tones into one another you can use a finger, a paper stump or a soft eraser.

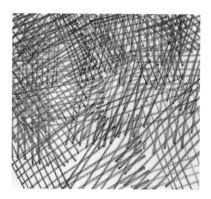

Cross-hatching builds tone and density in a controlled way.

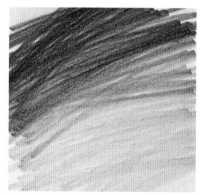

The heavier the pressure, the darker the tone.

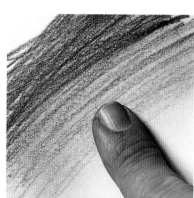

Vary and lighten tone by blending.

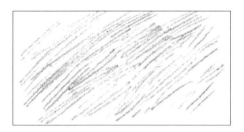

Light pressure

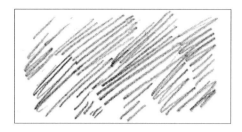

Firm pressure

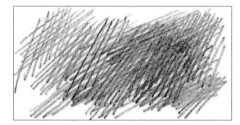

Cross-hatching

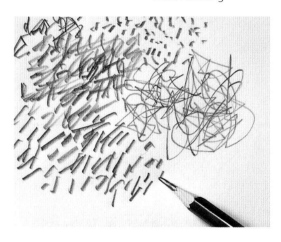

Texture

A single soft pencil is capable of a wide visual vocabulary. A number of textural effects are possible, utilizing a variety of marks such as dots, dashes, short jabbed lines, loose scribbles, fast scribbles, fat lines, thin lines, dark lines, light lines, ticks and squiggles.

Erasing

An eraser can be used to make corrections, as well as to produce specific tonal or textural effects. It can also be used as a tool to lift out highlights.

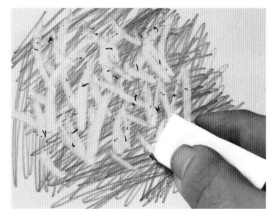

Continued on next page

Medium-grade pencil (2B)

Medium-grade pencils are the artist's 'workhorses', coupling flexibility with a sympathetic, soft mark. The best all-rounder is a 2B, but choose a 3B if you prefer a blacker effect. These grades soften very well but are not so soft that they smudge when being erased.

Soft pencil (6B)

Soft pencils from 4B upwards darken the surface beautifully and are expressive to use. Learn to keep your drawing hand off the paper as you work, since they tend to smear across the paper. Erase with care, since they smudge if attacked too vigorously.

Graphite stick (2B)

Graphite stick is the drawing tool for covering large surfaces quickly. You can buy most grades up to 9B as sticks. Try to use the side of your stick for rapid darkening, scraping the glaze off its surface if necessary (see page 10).

Hard and soft pencils

This interior scene by David Arbus was built up gradually with different grades of pencils, starting with HB and 2B, and moving up the scale to 4B for the darkest details. Lost highlights were regained with a plastic eraser (see page 56).

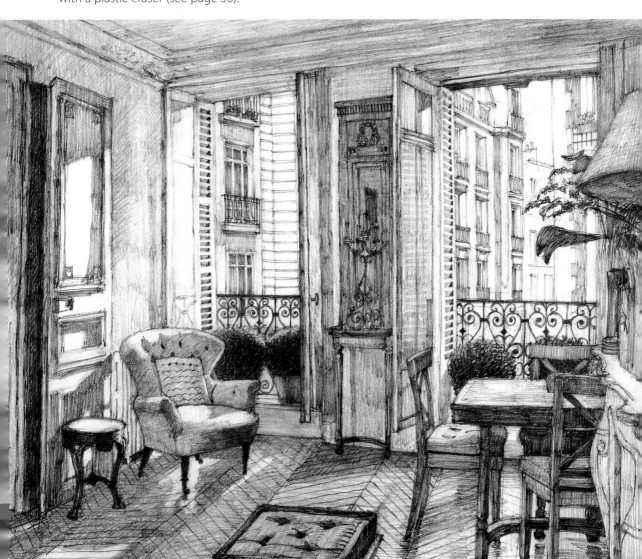

Charcoal and conté

Charcoal sticks are made in varying lengths up to six inches and are usually graded according to diameter. The charcoal is also graded as soft, medium or hard. Large rectangular blocks and thicker sticks known as 'scene-painters' charcoal' are also available, and are ideal for working on large areas.

Charcoal sticks can be messy to use, but if you don't mind dirty hands it is a very attractive medium. It is also very forgiving and easy to remove prior to fixing – a flick with a rag is all that is needed to remove most of the mark.

Compressed charcoal sticks and charcoal pencils

Compressed charcoal, sometimes known as Siberian charcoal, is made from powdered charcoal dust mixed with a binder and pressed into short sticks. These are substantially stronger than stick charcoal. Several manufacturers grade their sticks according to hardness: from the hardest (3H) to the softest (HB); and by blackness: from the blackest (4B) to the lightest (2B). Compressed charcoal sticks can also be found in a range of greys, the charcoal dust having been mixed with binder and chalk. They are available with both round and square profiles. Wooden charcoal pencils contain thin strips of compressed charcoal, and are found in grades of soft, medium and hard.

Charcoal is a messy medium, but you can keep your hands clean by wrapping foil around the stick.

To brush off charcoal or soften marks, a soft brush is an alternative to a rag. You can't do this after the drawing has been fixed, however.

Making oil charcoal

To make oil charcoal, simply soak a stick of charcoal in linseed oil for a few hours – or, better, overnight. Remove the charcoal, then wipe away any excess oil. Work as usual, and you will notice that the charcoal line will not smudge or need fixing.

Sharpening charcoal

Thicker charcoal sticks can be sharpened to a point with a sharp knife, a sandpaper block or fine to medium sandpaper sheets. Sharpen compressed charcoal with a knife or sandpaper, and use a sharp knife for wooden charcoal pencils. Some of the latter are wrapped in paper, which is removed by pulling a thread of string on the side of the strip.

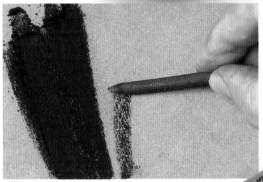

Conté pencils and sticks

These are available in a range of traditional colours: white, which is made from chalk; sanguine, which is made from iron oxide; bistre, a dark brown made by boiling the soot from burnt beech wood; sepia, which is obtained from the ink of the cuttlefish; and black, which is made from graphite.

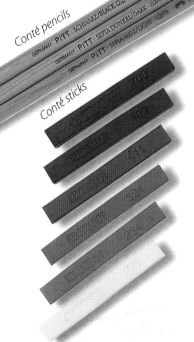

Conté pencils

Conté sticks

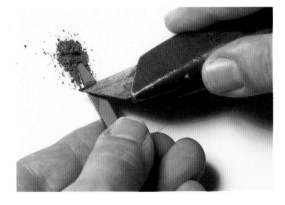

Conté sticks are sharpened using a sharp knife.

Using charcoal and conté

Line

Charcoal is an expressive material, and responds well to fluid drawing movements and variations in pressure. These characteristics make it possible to produce drawings that contain a great variation in line quality. Both regular charcoal sticks and compressed charcoal sticks can be used by bringing the side or the end of the stick into contact with the support.

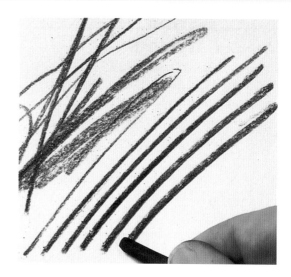

Thin stick charcoal produces expressive, linear strokes.

The thickness of the stroke can be varied according to the particular angle at which the stick is held.

Building up darks

In this powerful drawing, the charcoal has been used essentially as a linear medium, though there is a little smudging in the background. The intense blacks have been built up in several stages, with fixative sprayed on between each one, since it is seldom possible to create very dark tones with just one application.

Thick marks can be made by using the charcoal on its side.

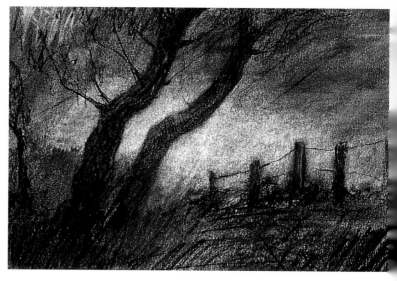

Hatching and cross-hatching

Areas of tone and texture can be built using a web of hatched (*right*) or cross-hatched (*far right*) lines or marks. These lines or marks can be very precise and controlled or loose and random.

Mark-making

Conté pencils can be used in the same way as graphite pencils or any other line medium.

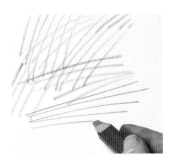
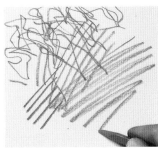
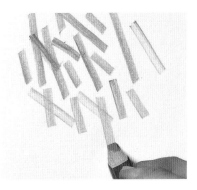

Used on its edge, a conté pencil makes thin strokes (top left). A conté stick makes expressive, linear strokes (top right).

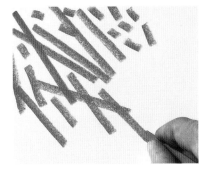

The conté pencil makes a solid, wide mark (top), while the unsharpened end of the conté stick makes a much darker mark (above).

The shape of the pencil allows for lines of varying width (top left). Altering the angle of the stick also results in different line widths (top right).

Continued on next page

Textural effects

Textural effects are easily achieved with charcoal: it is such a responsive medium that every tremor of the hand results in a well-defined mark. It is also valued for its ability to bring out the grain and texture of all but the smoothest paper.

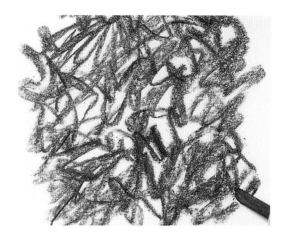

Constantly altering the direction of the mark results in a regular scumbled texture.

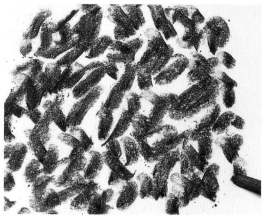

When used on rough paper, charcoal shows off the texture of the surface.

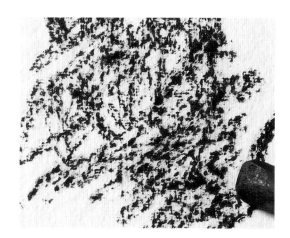

Irregular dots and dashes produced in varying densities suggest tone.

Used on its side, a thick stick of charcoal can cover a large area quickly and easily.

Tone

Areas of tone can be quickly scribbled or blocked in with wide strokes, using the edge of the stick. A full range of tone can be achieved by blending with a finger, rag, paper stump or brush.

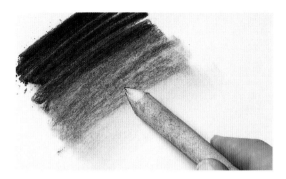

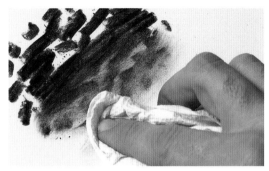

Here the charcoal is spread using a paper stump.

A finger wrapped in a paper towel makes a good blending tool.

Erasing

Charcoal is particularly receptive to being worked into with a range of various erasers. These will produce a variety of effects – from fine, crisp, sharp lines to texture and highlights.

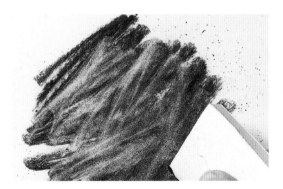

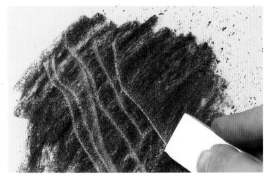

The use of a soft eraser results in a broad erased area, creating texture.

Hard vinyl erasers can create thin, sharp lines when used in charcoal.

SEE ALSO

Lifting out charcoal, page 56

Inks and pens

Ink is a wonderfully flexible medium that has been popular for centuries. It played a notable role in ancient Chinese art, and there is a Chinese saying, 'in ink are all colours', which refers to the wide range of tonal possibilities within a single ink colour.

However, ink does not have to be black or monochrome, since there are now many coloured inks available. These are perhaps less widely used than traditional blue, black and sepia inks, but they can add substantial interest to a drawing. They come in water-soluble and waterproof versions, and the latter can be used very much like watercolour and diluted with water to produce lighter tones. Acrylic inks can also be diluted with water, but will become waterproof when dry. These are made in wide ranges of colours, and can be mixed together to achieve further variations.

Waterproof inks

Non-soluble when dry, these inks are made using soluble dyes in a shellac base. They are denser than the non-waterproof varieties, dry to a slightly gloss finish and are capable of very precise work. The inks have a tendency to clog easily, however, and brushes and pens must be cleaned thoroughly after use (they must not be used in technical or fountain pens). Liquid acrylic inks are another type of waterproof ink, and unlike shellac-based inks, are made from pigments rather than dyes and are thus light-fast. They should not be mixed with the shellac-based variety.

Waterproof ink is diluted with water.

Shellac-based inks dry slightly glossy.

Non-waterproof inks

Non-waterproof inks do not contain shellac. When dry, they will soften and dissolve if washed over with water. They sink into the paper more than their waterproof counterparts, and then dry to a matt finish. They are widely used for laying washes over waterproof-ink drawings.

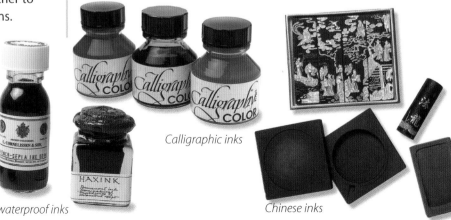

Calligraphic inks

Non-waterproof inks

Chinese inks

Liquid acrylic inks and liquid watercolour

Liquid acrylic inks are completely waterproof when dry, and most standard colours are light-fast. They are used in the same way as shellac-based waterproof inks, but cannot be mixed with them.

Acrylic inks are waterproof when dry.

Liquid concentrated watercolour is available in many colours, but like ordinary watercolours, may fade if subjected to bright light.

Liquid watercolour

Liquid acrylic inks

Bamboo and reed pens

Bamboo pens are cut from a short length of bamboo. They vary in thickness, and some are shaped so that they have a different-sized nib at each end. The nib makes a line of a consistent thickness with an irregular, coarse texture, which lends itself to bold approaches.

Reed pens have a far more flexible nib than bamboo, and can be easily re-cut and shaped using a sharp knife.

Dip pens and nibs

Dip pens that take interchangeable nibs are made from both wood and plastic. Shapes and sizes vary, so test a few out until you find one that is comfortable to use.

A wide range of nib shapes and sizes is available; not all fit into every dip pen, however, so make sure that your choice of nib will fit your pen. Nibs are made for specific purposes, but all nibs can be used for drawing, and several different nibs may be used during the course of a single work. If the nib seems reluctant to accept the ink, rub a little saliva onto it. A flexible nib allows for a range of line thickness and quality; simply vary the pressure applied to it.

Dip pens and nibs

Plastic dip pen

Quill pens

Quill pens are made from the large, primary flight feathers taken from the wings of birds such as swans, geese and turkeys. They are quite easy to make if you can find suitable feathers. They are more fragile than bamboo pens, and the quill will wear with use, requiring periodic re-cutting.

1 To shape a quill, first cut the underside at an angle.

2 Shape both sides of the quill equally.

3 Allow the ink to flow out by splitting the end.

Markers and felt-tip pens

An extensive range of marker and felt-tip pens is available in a wide choice of colours. Their only immediate drawback is that they may fade over a period of time, which would rule them out for any important work intended for exhibition. However, they are excellent for planning and preliminary work, and for drawings that won't be exposed to the light, such as sketchbook studies.

Markers are divided into water-based and solvent-based varieties, and both may have a different-shaped tip at each end, such as wedge-shaped, chisel-shaped or pointed. Different brands of markers can be mixed with one another, and a surprising range of interesting effects and colour combinations can then be made.

Brush pens

A relatively new product, brush pens have flexible, brush-like nylon tips that make fluid calligraphic strokes as opposed to the wedge-shaped marks produced by most markers. Many brands also have a fine-liner tip at the other end. These pens can also be used with traditional markers.

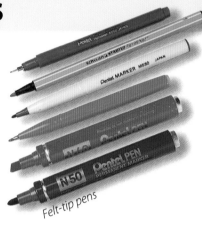

Felt-tip pens

Twin-tip pen

Brush pens

Solvent-based pens and markers

Up until recently, the only marker and felt-tip pens that offered any degree of permanence were solvent-based. This was a problem for those who suffer ill effects from solvents, but a great deal of research has been done on this, and today the available range of non-solvent-based pens and markers is much greater.

Marker pens

Felt-tip pen set

Art pens and fountain pens

Art pens resemble traditional fountain pens, and hold a cartridge that delivers a steady flow of ink to the nib. They are available with different-sized and -shaped nibs, giving a range of line thicknesses.

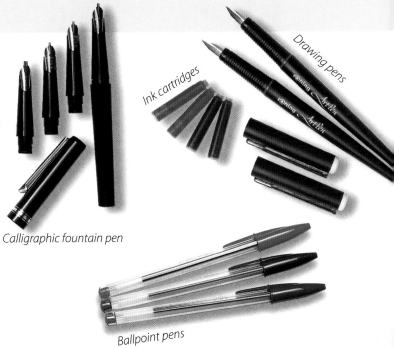

Ink cartridges

Drawing pens

Calligraphic fountain pen

Ballpoint and rollerball pens

The range of ballpoint and rollerball pens today is huge, and they make very useful drawing tools. Although only available in a limited nib size, they can be found in an ever-growing range of colours. Rollerballs tend to be slightly 'wetter' than ballpoints, and seem to deliver more ink. Both types of pens last a long time.

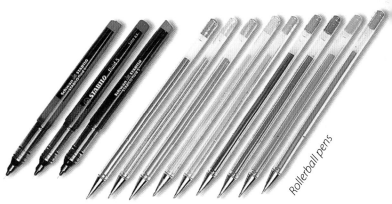

Ballpoint pens

Rollerball pens

ARTIST'S TIP

Nib pens are as delicate as they look. If dropped onto a hard or semi-hard surface, they may become permanently damaged. In the case of art or technical pens, this can become expensive, so be careful when using them. Even those inks designed to coagulate as little as possible can clog up a pen, so make sure you clean all pens thoroughly, even before taking a brief coffee break.

Ink-cleaning solvent

Using inks and markers

Working with ink has been likened to a trapeze artist working without a safety net, because any mistakes are difficult, if not impossible, to rectify. For this reason, the medium demands concentration and a decisive hand, but once mark-making in ink has been mastered, it is one of the most spontaneous and exciting mediums available to the artist.

When starting to draw in ink, try to make your marks and lines as confidently as you can, even if this means throwing away a drawing and starting again. In this way, you will begin to learn the technical aspects of the medium; for example, it is vital to know when to reload a pen or brush in order to achieve a flowing unbroken line, and this knowledge can only come through experience. You will probably get through a lot of paper, but the immediacy and straightforwardness of a good ink work makes the effort and expenditure worthwhile. One tip for beginners is to make a light drawing in soft pencil or charcoal as a guide for the pen work, and another is to practise making the line on a spare piece of paper before making it on the actual drawing itself.

Dip pen

The dip pen's capacity to accept a wide range of nibs makes it an extremely versatile tool.

Bamboo pen

A bamboo pen runs out of ink quickly, and can feel dry and stiff as it moves over the paper surface.

Quill

The natural feather quill makes a range of unique marks.

Art pen

These pens are quick and clean to use, making them good sketching tools.

Ballpoint pen

Ballpoint and biro pens produce lines of uniform width.

Technical pen

The line made by this pen is of uniform width, with the paper lying on a smooth surface.

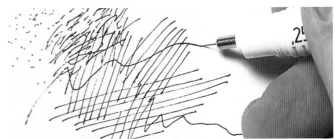

Marker pen

Marker pens of different shapes and sizes can produce a wide variety of marks.

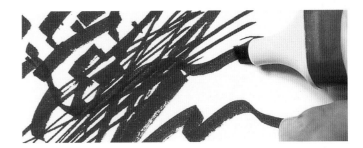

Brush pen

Brush-pen marks vary in thickness, according to the amount of pressure applied.

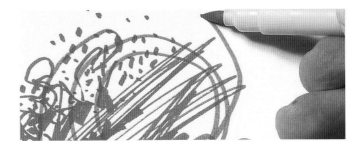

Oriental brush

This type of brush, made specifically for drawing with ink, creates very expressive marks.

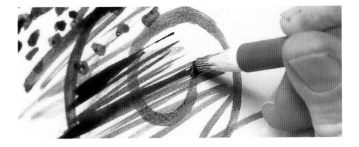

Continued on next page

Pen line

The flexibility of the dip pen results in expressive lines in an extensive variety of widths.

Wash

Pen line coupled with a brush wash is a classic combination of techniques.

Pen and brush tone

Water-soluble inks can produce a wide range of tones according to the amount of water used to dilute them.

Tone through line

Hatching and cross-hatching are the traditional methods of building up tone in a pen and ink drawing.

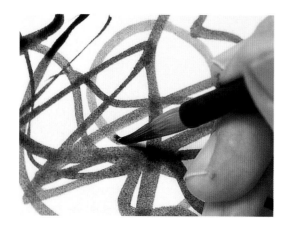

Brush and ink

Inks can be used with brushes as well as pens (see page 68). Here, an oriental brush is used. These are held differently to western brushes, at right angles to the paper, and the hand does not rest on the work – the movement comes from the whole arm, not just the wrist. This allows for very fluid line work, but requires some practice.

Texture

In order to create texture, ink can be spattered or dabbed on with a sponge, rag or finger. Coarse fabric can also be used to make imprints, as can leaves, feathers or anything else with definite texture of its own. Try using watercolour-resist techniques with a wax candle or spirit solvent (see page 108), or try masking techniques using masking fluid (see page 88).

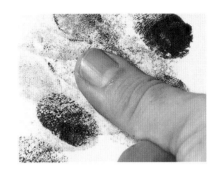

The thumb can be used to make imprint marks, thereby adding interest and texture.

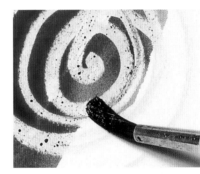

A clear wax candle is used to draw the design, which is then washed over with diluted ink.

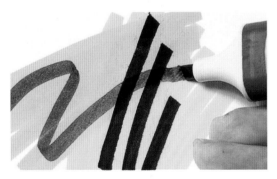

Working with markers

Depths of colour can be built up by laying one marker colour over another, working from light to dark as with watercolour.

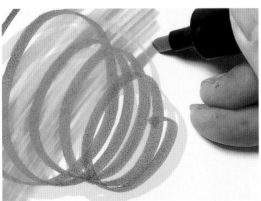

Blending pens

These contain a solvent, and are produced for the purpose of mixing marker colours on the paper surface.

SEE ALSO

Blot drawing, page 62
Brush drawing, page 68

Coloured pencils

1

The artist working with coloured pencils now has a wide range of high-quality materials to choose form. Every brand of pencils has its own handling qualities – the pencils are usually sold individually as well as in sets, so it is worth trying out a few different styles. There are variations of texture, and the colours available vary between brand-name products, so you should keep in mind the versatility of the palette if you decide to buy an expensive boxed set. The surface finish of the paper you use also significantly affects the pencil application. Some artists like a grainy paper with a rough tooth that breaks up the colour; others prefer a smoothed-out finish that leaves all the textural qualities dependent on the way the marks are made. Ordinary drawing paper is fine for practising your skills and is often used for finished work. But if you want to get a special effect, making use of the paper grain, check out the variety of papers sold primarily for watercolour and pastel work.

These are the essential ingredients; however, you also need a few other materials. The items shown here represent basic studio needs and the different types of pencils available.

3

Types of pencil

1 Chalk pencils have a velvety, pliable texture ideal for blocking in and blending.

2 Wax pencils in the softest grades create subtle effects of shading and colour gradation.

3 Water-soluble pencils can be used wet and dry, providing a high degree of textural variation.

4 Wax pencils of a slightly harder consistency are versatile for line work, hatching and shading.

5 Hard pencils with fine leads are well suited to drawing intricate detail, and to the technique of impressing.

4

2

5

Different approaches

Coloured pencil allows for an almost infinite range of styles, and these two drawings show very different approaches. Jane Strother (*below*) has used soft, waxy pencils very loosely to create an energetic, sketchy effect, mixing colours on the surface in places. Jane Hughes (*left*), in contrast, has built up her detailed drawing in layers, using a large palette of colours straight from the box and relying very little on surface mixing, which can reduce the intensity of the colours.

Using coloured pencils

Coloured pencil is naturally a line medium, although there are many ways of building up areas of solid and mixed colour. Hatching and cross-hatching are traditional methods of creating effects of continuous tone using linear marks. With a colour medium, they can also be a means of integrating two or more hues and producing colour changes within a given area.

Hatching simply consists of roughly parallel lines, which may be spaced closely or widely, and with even or irregular spacing. In monochrome drawing, the black lines and white spaces read from a distance as grey – a dark grey if the lines are thick and closely spaced, a pale shade if the hatching is finer and more open. The effect is similar with coloured lines, the overall effect being an interaction between the lines and the paper colour.

Cross-hatching is an extension of hatching in which sets of lines are hatched one over another in different directions, producing a mesh-like or 'basketwork' texture. Again, an area of dense cross-hatching can read as a continuous tone or colour.

Hatching

The technique of hatching can be clean and systematic or free and variable. The lines can be of relatively equal weight and spacing (*below left*) or may vary from thick to thin, with gradually increased or decreased spacing (*below right*).

Cross-hatching

The denser the texture of cross-hatching, the more options you have for developing shading and colour. Using different colours cross-hatched (*below left*) adds tonal and colour interest. The same colour cross-hatched creates an integrated network of lines (*below right*) that can be straight, curved or directional.

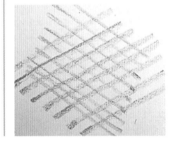
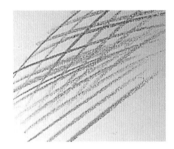

ARTIST'S TIP
For fine detail and intricate overlays of colour, always keep the pencils well sharpened, since they wear down quickly. Blunt pencils are better for broad effects and thick lines; you can blunt the points deliberately by rubbing them over a piece of scrap paper.

Free-hatching

The lines of hatching do not have to be distinct and separate. Here, the second layer of colour is hatched over the first with a free scribbling motion.

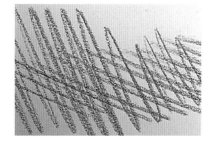

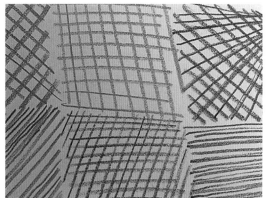

Varying the texture

Different qualities of shading and texture are developed by varying line, weight and spacing, and by combining colours. Lines that are converging rather than parallel suggest space.

Working on textured paper

John Chamberlain has made clever use of linear techniques both to model the form of the gymnast's body and to give a feeling of his forward momentum. The grainy paper enhances the patterned effect of the hatching and cross-hatching.

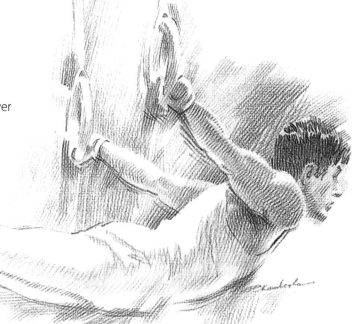

Continued on next page

Blending

There are various techniques for blending colours effectively. The method you use will depend on whether you want smooth gradations of colour and tone, a layered effect built up by overlaying colours, or an optical mixture created by massing linear pencil strokes to produce overall colour blends, as with hatching or stippling.

Using solvent you can obtain effects closer to the fluid colour blends typical of paint media, while burnishing heightens the effect of graded and overlaid colours. Refer to all these techniques to familiarize yourself with their different surface qualities, so you can choose the method best suited to an individual work.

Blending with waxy pencils

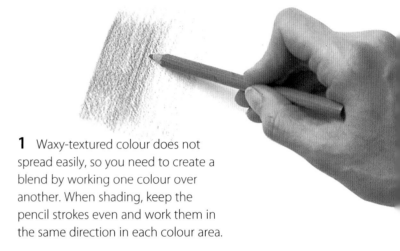

1 Waxy-textured colour does not spread easily, so you need to create a blend by working one colour over another. When shading, keep the pencil strokes even and work them in the same direction in each colour area.

2 By overlaying the colours, you create a third colour that merges the hues of the first two. You can shade lightly, as in this example, or rework the colour layers until you fill the paper grain.

Blending using cross-hatching

An alternative method of blending is to use the technique of cross-hatching. Apply a different colour each time you change the direction of the set of hatched lines.

Blending with chalky pencils

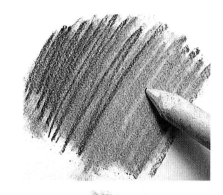

2 Use a paper stump (see page 10) to spread the colour, and press it into the paper grain by rubbing gently but firmly over the pencil marks. As an alternative, you can rub with your fingertip or a cotton bud.

1 The texture of chalky pencils allows the colours to be blended by rubbing. You can begin by working one colour over another with loose hatching.

3 In this example, the blended colours show the direction of the original hatching, creating a soft but active surface effect.

Blending flat colours

To blend flat colour areas, begin by laying down areas of solid shading. Then, using the paper stump, soften the transition from one colour into the next.

Pastels

Pastels are made by mixing pure pigment together with an inert extender, such as French chalk. (Oil pastels are different in kind, and are dealt with later in the chapter.) The pastel is held together with a weak binding medium, usually gum tragacanth, obtained from a shrub found in the Middle East. Adding various amounts of titanium white or zinc white to the pure colour pigment results in a range of tones of each colour; the more white added, the lighter the tint.

ARTIST'S TIP

Hard and soft pastels are often used together, with the former being best for establishing broad areas of colour in the early stages of a work. If used fairly lightly on their sides, they don't fill the grain of the paper as quickly as soft pastels, and thus can provide a good foundation for further layers.

Soft pastels

Soft pastels are the most commonly used type, and offer the largest choice of tints and tones. Most have a round profile, and are usually about 5–7.5cm (2–3 inches) long. They usually come wrapped in paper to help keep them together, as certain brands are extremely soft and can break very easily.

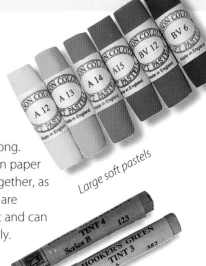

Large soft pastels

Small soft pastels

Dry pastels crumble easily.

Hard pastels

Hard pastels are normally square-sectioned, and are not wrapped in paper. Their relative hardness is due to more binder being used during the manufacture, and results in less crumbling and shedding of pigment powder. They are ideal for linear work, and can also be used on their sides to produce broad areas of colour.

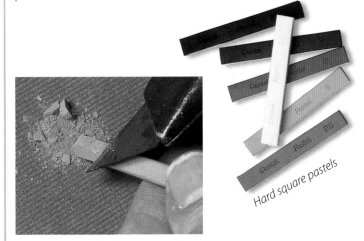

Hard square pastels

Hard pastels can be sharpened with a craft knife or razor blade.

Pastel pencils

Pastel pencils are made of a strip of hard pastel secured inside a wooden case. Although they can cover large areas with tone and colour, they really come into their own when used for line work. They are also great for working in detail with soft or hard pastels, and are excellent for sketching.

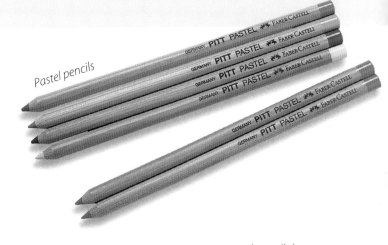

Pastel pencils

Pastel pencils are harder than soft pastels but softer than coloured pencils.

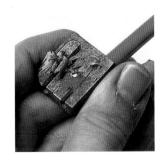

A pencil sharpener or knife can be used to sharpen pastel pencils.

Pastel sets

Pastels can be bought either individually or in boxed sets. Some sets offer as few as 12 colours, while others offer many more. Some manufacturers also produce boxed sets geared specifically towards artists who wish to paint certain subjects, such as landscapes and portraits, the former containing more earth colours and skin tones and the latter a wider selection of greens and blues.

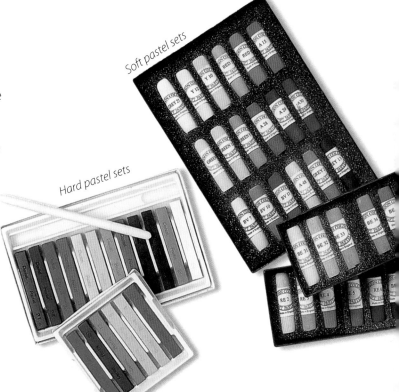

Soft pastel sets

Hard pastel sets

Using pastels

There is nothing quite as inspirational as a large tray or box containing a range of new, bright-coloured pastels. Using pastels is almost like having colour pour from your fingertips. The medium is unique in that it takes many of its techniques from both painting and drawing. A pastel stick can be used on its side to create broad, painterly strokes that emulate those of an oil painting, while working with the tip of the stick allows you to make thinner, crisper marks. Pastel is an amazingly versatile medium, capable of producing anything from large-scale painterly works to highly detailed drawings. They also work well with other media such as watercolour, acrylic and charcoal, and are often used in mixed-media pieces.

ARTIST'S TIP

Pastel drawings, especially those in soft pastel, are fragile and need to be stored carefully to prevent the pigment from smudging or falling off the paper. Lay the completed drawing on a sheet of tracing paper or acid-free tissue paper larger than the drawing, fold the excess over onto the back and secure it with small pieces of masking tape.

Linear strokes with hard pastels

Linear strokes are usually made using the end or sharp edge of the pastel. These marks can be mechanical and precise or loose and expressive.

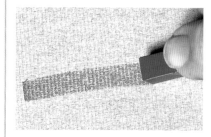

Making a stroke using the square end of a pastel results in a bold, thick line.

The sharp corner of a pastel stick gives a finer, much more delicate line.

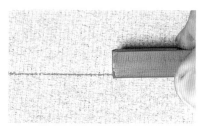

Applying the pastel on the edge which runs down its length results in a straight line.

Using the edge of a pastel, but changing the angle gives a line of varying width.

Side strokes

Side strokes are used to lay in broad, sweeping areas of solid colour or to lay one colour over another. You can either use the whole of the pastel or a shorter length that has been broken off. The amount of pressure applied determines how much pigment is transferred to the working surface.

Used on its side, the pastel makes a broad area of colour.

The side of the pastel can also be used to lightly glaze one colour over the other.

Hatching and cross-hatching

Hatching is a traditional linear technique used to build up tone and solid colour. It is less often used for soft pastels than blending methods, because the soft, powdery colours are so easy to rub together, but has applications for both hard pastels and pastel pencils. Hatching need not look mechanical: lines can be scribbled rapidly and at any angle. The important thing is to keep an open feel to the network of lines, allowing the underlying work to show through.

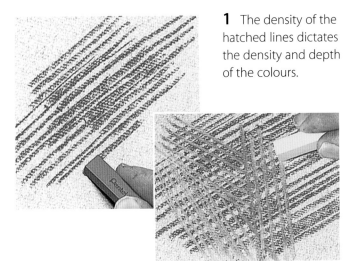

1 The density of the hatched lines dictates the density and depth of the colours.

2 Crossing one set of lines with a completely different colour results in a surface mixture.

Continued on next page

The powdery quality of pastel makes it possible to blend two or more colours together easily, thus creating other colours. The blending action can also be used to soften and blur edges, modify tone, model form and to create a range of soft textures and effects. Blending should not be over-used, however, or the work will take on a 'soft-focus' look, and will lack bite or depth of colour. Artists often use linear techniques over and in combination with soft blends to bring certain areas into focus.

Blending can be done with a finger, brush, rag or a paper stump (see page 10). When using pastels prior to blending, take care not to build up too thick a layer, and don't push the pastel down into the paper texture, since the ingrained pigment is difficult to manipulate. It is also important to blend colours before fixing them.

Blending with a brush

Colours can be blended with a stiff bristle brush, but this may knock the pigment off the paper.

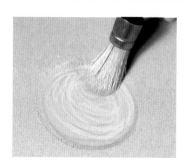

Finger blending

The finger is an ideal tool for blending, since the slight grease pushes the colours together rather than brushing them off the surface.

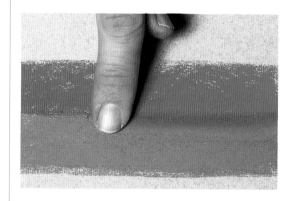

Varying tones

The finger can also be used to effectively vary the tone density.

SEE ALSO

Wet brushing pastel, page 94

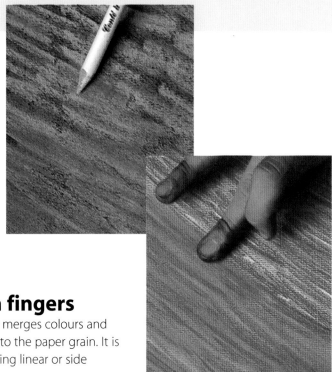

Blending with a paper stump

Lay down the pastel colour and gently rub the surface with the tip or side of the stump to soften and blend the colours.

Blending with fingers

Rubbing with your finger merges colours and presses the pastel dust into the paper grain. It is an effective way of blending linear or side strokes in soft pastel.

ARTIST'S TIP

With oil pastels and hard pastels, which do not spread so smoothly on the surface of the paper, use short strokes to overlay one colour on another, varying the pressure so that the integrated marks produce an impression of mixed tones.

Fixing

Fixative should not be seen solely as a means of protecting pastel drawings on completion. Used at various times in the course of a work, it enables you to build up colours in several layers without disturbing or mixing with previous colours. It is important to remember that fixative will darken light colours, 'knocking' the pigment back into the paper (some artists avoid fixative for this reason), but this tonal shift can be seen as beneficial in that you can extend your palette of colour simply by fixing some areas and not others.

Oil pastels and paint sticks

Oil pastels superficially resemble the wax crayons so familiar to children, but are far more sophisticated, with the better brands containing more pigment and being much more flexible. Oil pastels are an exciting medium for anyone who enjoys a broad approach, and one of their advantages over soft pastel is that they don't require fixative. They are also harder than dry pastels, and thus crumble less, but are more difficult to blend unless a solvent is used.

Paint sticks, which are really oil paint in stick form, are a more recent innovation. These, sometimes called oil bars, are best suited to broad work, since they are considerably thicker than pastel sticks and can't easily be controlled over small areas.

Oil pastels are made by mixing pigments with an oil-soluble wax and a non-drying binder, which both hold the pastels together. After manufacture, they are enclosed in a wrapper that not only provides support but also helps keep the user's hands clean. Paint sticks are made from fine-quality pigments blended with drying oils and specially blended waxes.

Oil pastels

Depending on the characteristics of the pigments used, oil pastels can be opaque, semi-transparent or transparent. A strong colour range is available, and rich colours can be achieved with the minimum of layering.

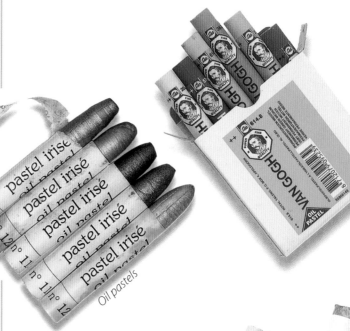

Oil pastels

Paint sticks

Like oil paints, these sticks are sold in series according to the cost of the pigments used, and are coded according to permanence. Some paint sticks are thixotropic, with the colour becoming thin and creamy when rubbed onto the support with pressure and speed. Paint-stick sizes vary by brand, but can generally be categorized as small, medium and large.

Paint sticks are available in a wide variety of sizes.

Oil pastel boxed set

Opaque and transparent colours

Some colours are much more opaque than others. Cadmium red is very opaque, while ultramarine is semi- transparent and yellow ochre is transparent.

Cadmium red Ultramarine Yellow ochre

Manufacturer's colour chart for oil pastels

The first manufacturer to produce paint sticks called them oil bars, and they are still known by this name. They have the same characteristics as other paint sticks.

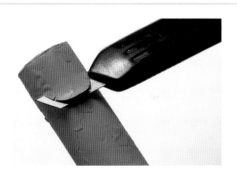

The stick develops a thin film over its surface, which needs to be removed before use.

Oil-bar boxed set

Using oil pastels and paint sticks

Oil pastels and paint sticks are quite robust, and encourage a bold, direct approach. Generally speaking, they are not suitable for creating smaller-scale, detailed drawings; the sticks are simply too chunky. It is best to work on a large scale, using vigorous strokes. Most of the techniques used for oil painting can also be used with both oil pastels and paint sticks, and several of the techniques that work especially well with oil pastels and paint sticks are shown here.

Mark-making

Oil pastels can be used to create combinations of linear and side-strokes in exactly the same way as soft pastels. Because of their solidity, paint sticks can retain a reasonable edge or a bullet-shaped point, thereby facilitating various linear strokes as well. Although paint sticks are difficult to use on their side; they are usually thick enough for the colour to be spread easily, enabling large areas to be covered with colour quickly.

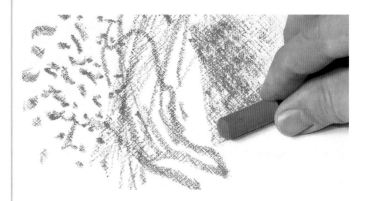

Oil pastels can be used to make fine linear strokes, or they can be used on their sides to block in large, solid areas of colour.

ARTIST'S TIP
Unlike oil paints, oil pastels and paint sticks can be used on an unprimed surface, since their constituents don't corrode paper or fabric. The papers sold for pastel work are a popular choice, or if you like a heavier texture, try watercolour paper.

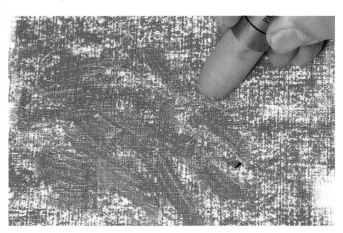

Paint sticks can be built up in layers like traditional oil paint.

Scumbling

In this technique, one or more colours are applied over one another in light veils, so that each colour partially covers the one below. It is an especially useful technique for colour-mixing in oil-pastel work, because the colours can't easily be mixed by blending.

1 This technique is essentially free and broad, but it can also be controlled. It is used here to create a cloud effect.

2 Various light-toned oil pastel colours are scumbled over one another, using side-strokes in different directions.

If you want to varnish completed drawings done in oil pastel or paint sticks, it is best to use varnishes specially sold for use with these mediums. Oil-paint varnishes could dissolve the wax content of the pastels and sticks.

Using blending sticks

Most manufacturers of paint sticks produce a colourless bar for blending. Rubbing a blender bar over a work has the effect of smoothing out the colour without making it lighter – the bars, in fact, make the colours more transparent, since they are made from wax and oil. The bars are manufactured specifically for use with paint sticks, but can also be used with oil pastels.

Continued on next page

Using mediums

Solvents and mediums sold for use with oil paints can also be used with oil pastels and paint sticks, increasing the potential of the mediums. The solvent most commonly used with oil pastels is turpentine (or white spirit), which melts the colour and allows you to spread it out to create painterly effects. You can either dip the pastel stick into the solvent to make the colour flow more easily, or you can work into a drawing with the brush dipped into the medium. The solvent can also be applied to the surface to wet it before applying the pastel colour.

Blending on the paper surface

Here, you can see the effect of working into oil pastel with a brush dipped in solvent.

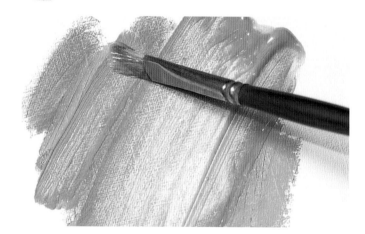

Wetting the surface

The surface has been wetted with white spirit, making the oil pastel glide onto it easily. The second and subsequent colours are easy to blend while the surface is still wet.

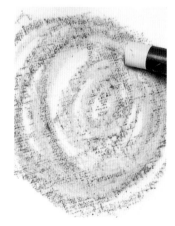

Blending paint sticks

Paint-stick colour is thick, but it can be blended without solvent using a stiff bristle brush.

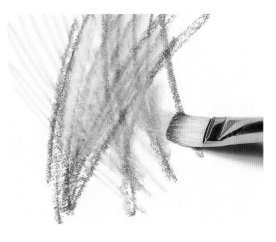

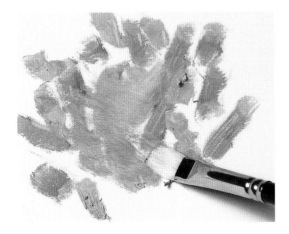

Paint sticks are easily blended together with the help of a dry brush.

Sgraffito

The consistency of oil pastels and paint sticks is perfect for sgraffito or scratching techniques. Colour can be scraped off to leave large areas of textured surface. Alternatively, a range of linear effects can be made by scraping and scratching through layers of paint, as shown on page 80.

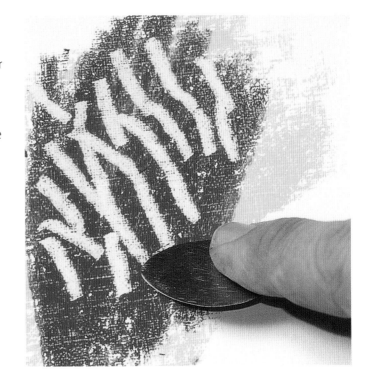

Drawing papers

The surface of a particular paper has a strong influence on the finished effect of a drawing. The most commonly used paper for pencil and coloured-pencil drawings is 'cartridge' or drawing paper, which has a smooth surface, but some artists prefer to work on a more heavily textured paper such as those made for watercolour and pastel. If pastel is your chosen medium, you will have to work on textured paper because the powdery pigment will simply fall off if there is no 'tooth' to hold it.

All papers are sold in loose sheets of various sizes as well as in sketchbooks in both landscape and portrait formats. Sketchbooks are a must for any location work, and you may like to buy one or two with different papers so that you can vary the media. For indoor work, sheets are a better choice, since they can be cut to any size you like, but ultimately the choice of surface depends on the kind of work you intend to do.

15 *Neutral shades are easy to use, but brightly coloured papers are good to try when you want to influence the overall warmth or coolness of your colour scheme, or to create a base to shine through coloured pencil or pastel.*

1 *Small- or medium-sized sketchbooks can travel with you in a bag or pocket.*

2 *A large sheet of handmade heavyweight (not-pressed) paper.*

3 *Rough paper with a pronounced tooth and cream tint.*

4 *A specially created hammered effect in rough white paper.*

5 *Heavy, hot-pressed paper in an off-white shade.*

6–8 *Medium-weight, hot-pressed papers in cream, green and grey.*

9–10 *Lightweight, mould-made Ingres papers for pastel work in beige and blue-grey.*

11–14 *Lightly sized, absorbent heavyweights in green, cream and two tones of buff.*

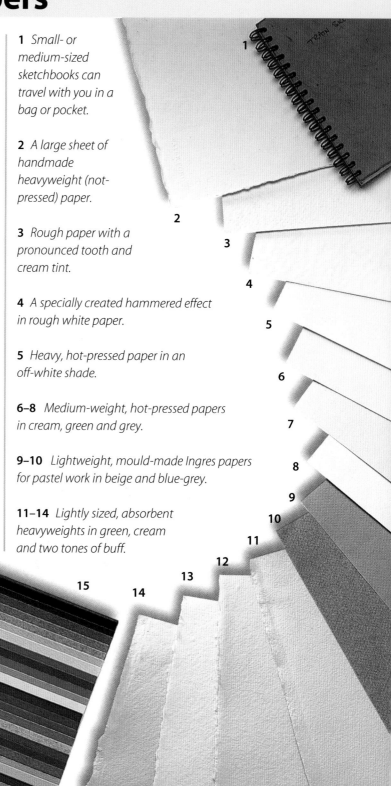

Large pads can be taken out for major works when you need extra space for big subjects, or several small sketches together on one sheet.

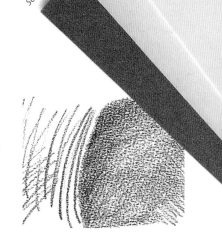

Pastel board

Velour paper

Artist's sandpaper

Special pastel papers and boards

The long-established Ingres and Canson Mi-Teintes brands are some of the most popular pastel papers, but many others are available as well. Schminke's Sansfix pastel board comes in six surface colours: Sennelier makes a heavy board in 14 colours and Frisk produces a range of boards in 14 colours. Two other alternatives are artist's sandpaper and velour paper, which has a velvety texture. All these papers are usually sold as individual sheets, or in packs that contain a range of colours.

Paper-grain effects

In these coloured-pencil examples, you can see the effect of the surface texture.

1 Drawing paper is quite smooth, and does not break up the pencil strokes.

2 Mi-Teintes paper, made for pastel work, has a very pronounced, quite mechanical grain.

3 Heavy watercolour papers sometimes prove too resistant for coloured pencils or pastels, since it takes a long time to fill the grain with colour.

Coloured papers

Use of a coloured background is a traditional aspect of pastel work (and light tints are also sometimes used for coloured-pencil drawings). Because the grainy texture of pastel usually allows the colour of the support to show through, it is not always appropriate that this colour should be white, since small specks of white showing through the marks can be distracting. A coloured ground can be used to set an overall tonal value for the work – dark, medium or light – or to give it a colour bias in terms of warm (beige, buff, brown) or cool (grey, blue, green) colour. It can stand in for a dominant colour in the subject – blue or green for landscape, for example; buff or terracotta for a townscape. Subtle hues are typically selected, but there are occasions when you might choose a strong colour to isolate the image and throw it into relief.

Neutral tints

Neutral tints such as beige, buff and grey provide a mid-toned background that enables you to key your range of pastel tones and colours. These can give the pastel rendering a cool cast, for instance blue-grey; or a basic warm tone, as with an orangey-buff paper.

Bright colours

Colours that are bright or very densely saturated make a strong impact on the overall image, intensifying the hue and texture of the pastel marks.

ARTIST'S TIP
If you like working with pastel on watercolour paper but don't want a white surface, you can tint it with watercolour or diluted acrylic paint. If the paper is thin you will need to stretch it first to prevent it buckling. Wet it all over with a sponge, place it on a drawing board and stick adhesive-paper tape (not Sellotape or masking tape) along each edge.

The influence of paper colour

Both the hue and tone of the paper influence the effect of applied pastel colours. If you practise making tint charts like these (*below*) you will be able to predict and make use of different effects. Notice, for instance, how the yellow patch appears much more vibrant on the dark grey paper than on the buff, and the brown pastel comes up surprisingly light-toned on a dark grey or red background. The red paper gives greater intensity to the greens, because the colours have complementary contrast.

2
Further
techniques

Tonal drawing

Just as you can draw purely in line, so you can also make drawings entirely in tone. Certain drawings by Georges Seurat are excellent examples of this approach. He used conté crayon (see page 16) to describe the overlapping planes of light and shadow; in other words, the tones rather than the outlines of his subject. Drawings like these, conceived in tone and carried out using a tonal medium such as wash, conté or charcoal, are full of mood and atmosphere. By studying the way an object is illuminated and by recording the resulting tonal pattern, the artist can recreate the solidity and appearance of three-dimensional form. To help you see the tonal relationship in a subject, a good exercise is to make a collage of it using pieces of toned paper as shown opposite. Newspaper photographs can be torn up to represent patches of tone and glued into position as a collage to render accurately the tonal patterns of the subject. Alternatively, you can shade pieces of tracing paper with different grades of pencil.

Tone with charcoal

Charcoal has been used freely to describe the trees and a dark sky in a winter landscape. To convey both the starkness of the scene and its less defined aspects, the charcoal was smudged with a finger for the sky, while elsewhere it was drawn directly and left untouched.

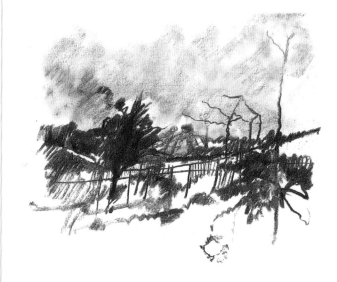

Tone with brush and ink

A great variety of tones can be produced rapidly with a brush and diluted black ink. This view through a window illustrates the importance, when using the technique, of concentrating on the main tonal areas rather than on details.

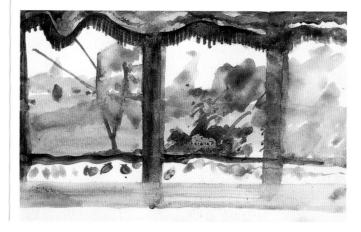

Drawing with cut paper

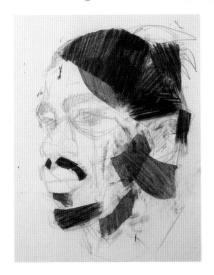

1 The artist has prepared five tones by hatching onto tracing paper with soft pencils and one charcoal pencil used heavily for the darkest tone. She started with a pencil drawing and then began to establish the dark tones with torn pieces of paper.

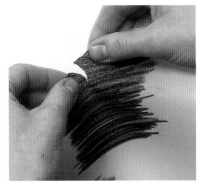

2 Thin tracing paper was used, because it is easy to tear to the required shape. Tearing is not only faster than cutting; it also gives a freer, more drawing-like feel to the image.

3 Having established the broad masses, she adds smaller pieces of mid-toned paper to define the facial features and hair.

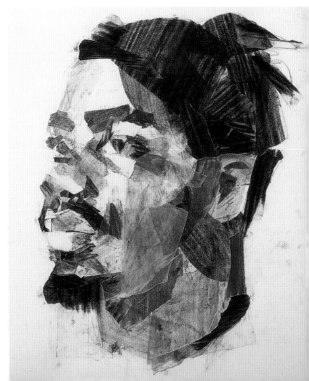

4 In the final stages, the shadow over the cheekbone was seen as over-dark, so a layer of clear tracing paper was used on top. The finished collage is a lively and remarkably accurate study of form.

Lifting-out charcoal

Charcoal is regarded as one of the most flexible and expressive of all drawing media. The range of tones possible, from pale silver-grey to rich velvety black, constitute only part of its appeal. It is often recommended for beginners, especially when drawing the figure, because it encourages a bold approach and is very easy to correct. The ability to remove charcoal from the paper so cleanly has given rise to an interesting technique in which the drawing is worked in reverse, from dark to light. For the lifting-out method, the whole paper is covered with charcoal and then removed with a putty eraser to achieve whites, near-whites and pale greys. Any tones that have become too light in the process can simply be corrected by adding more charcoal. A putty eraser is a surprisingly sensitive drawing tool: it can be shaped into a point to produce fine lines as well as used on its side for larger areas.

1 The basic lines were roughed in with thin sticks of willow charcoal, compressed charcoal and scene-painters' charcoal (see page 16). The artist begins with bold linear marks and then exploits the softness of the medium by rubbing with a finger.

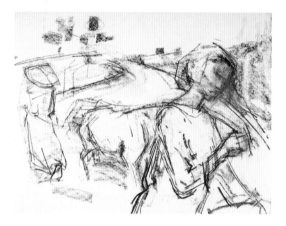

2 She is working on a rough handmade paper to give texture to the drawing, and now rubs on scene-painters' charcoal to cover the paper with grey and black tones. Because of the texture of the paper, the surface does not become too clogged, and the white breaks through in places to keep the drawing fresh.

3 She now works back into the drawing with a putty eraser to lift out the paler tones. The edge of the eraser produces hatched strokes that are utilized to model facets of the forms.

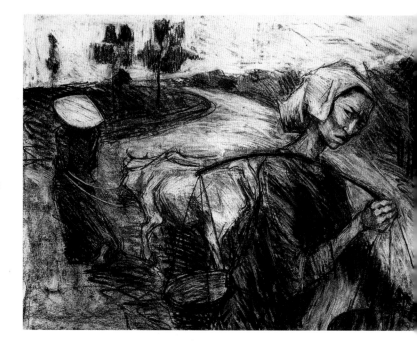

4 Thin sticks of charcoal and compressed charcoal are skillfully manipulated to re-establish the original lines and shapes.

5 The soft, dense black line produced by compressed charcoal is used in the final stages of the drawing to reinforce the dark tones, and the eraser is brought into play again to define and strengthen the head and hand of the foreground figure. This powerful image is a good example of how an eraser can be used positively as a dynamic mark-maker rather than only for correcting mistakes.

Featured drawings

Dramatic effects

Charcoal, handled with bold gestural movements, created this powerful image of Vietnamese refugees. Once the basic shapes had been established with broad strokes, the artist covered the whole drawing with a dense layer of charcoal. She then worked back into this with an eraser, lifting-out broad highlights, almost as if carving out the forms. The finished drawing has a simplified tonal range, the dark tones massed together to unify the image and add impact.

The drawings on these pages show how two artists can use the same medium and technique to produce very different results, one dramatic and disturbing and the other delicate and sensitive.

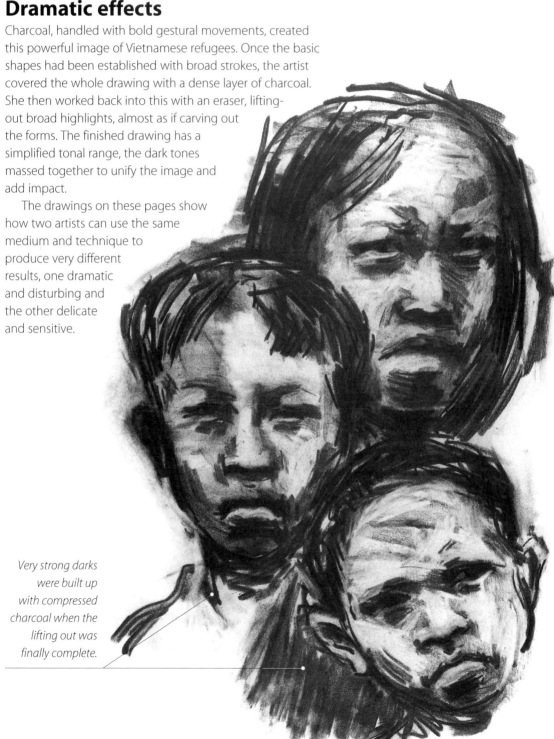

Very strong darks were built up with compressed charcoal when the lifting out was finally complete.

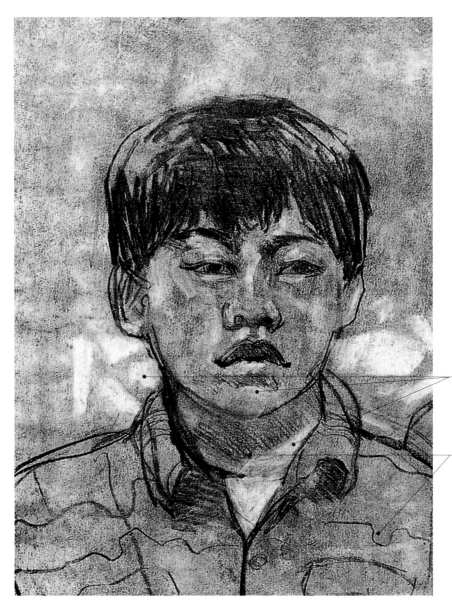

Highlights lifted out from the overall grey tone.

Hatched and curved lines have been added in thin willow charcoal.

Adding linear detail

In this drawing, the lifting-out technique has been used more sparingly, to create highlights on the face and neck and touches of interest in the background that help to unify the image. The artist has used the charcoal more lightly in the first stage, so that the paper is an overall grey rather than black and the darks that define the hair, features and shirt have been added with thin sticks of charcoal after the lifting out is completed.

Shading

Shading refers to the tonal elements in a drawing rather than the linear ones. For example, wherever light falls on an object, you would need shading to indicate areas of tone, representing the parts of the subject in shadow, and to give them solid form. Although shading can be done successfully with hatching or cross-hatching, less linear methods of applying tone are often preferred. Pencils or charcoal sticks can be used on their sides to produce solid patches of tone. Sensitive shading with continuous tones does more than simply define the shape of an object – it can also create the illusion of three-dimensional reality, the greatest of all the artistic 'tricks.'

Shading with conté crayon

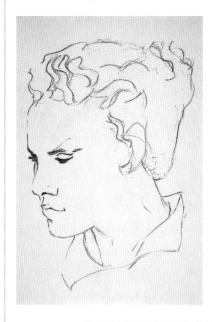

1 After the main outline of the portrait has been sketched on cream paper, a black conté crayon is used to establish the main features.

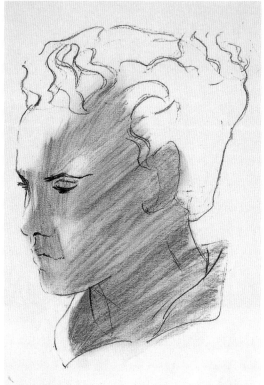

2 Using a red-brown conté crayon the basic areas of tone are shaded in. These hatched lines establish the main planes of the face.

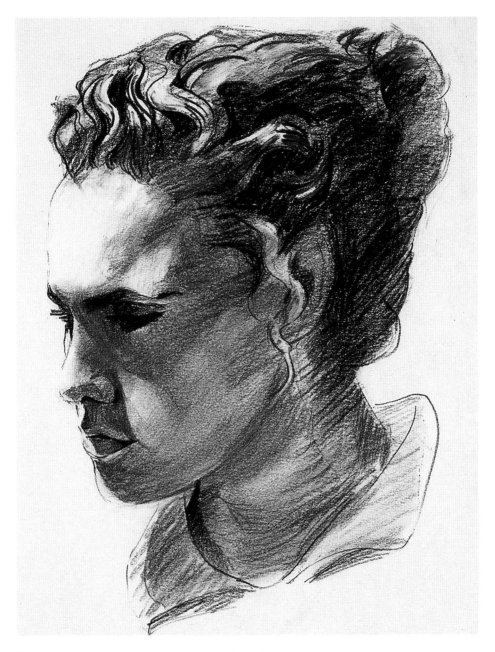

3 The shading is then strengthened with black conté crayon, and a finger is used to blend the tones in places. Notice how the hatched lines on the side of the face follow the direction of the forms.

Blot drawing

The use of the blot and its unpredictable nature as a means of making art has a long history. In 1786 the English painter Alexander Cozens devoted a whole book to it. Called *A New Method for Assisting the Invention in Drawing Original Compositions of Landscapes*, the book demonstrated how the ink blot could be used by artists to improve and enliven the usual formulae by which they composed their paintings. A group of blots scattered onto paper could, wrote Cozens, produce an 'assemblage of accidental shapes from which a drawing may be made'.

The blots can be dropped onto the paper from a brush, a pen or stick; and the effects can be varied by dropping onto dry or wet paper. It is possible to build up a complete drawing using this technique, but it is more usual to use it to create a particular effect in one section: for example, to represent foliage in a landscape drawing.

Imprinting

To produce these blots, absorbent kitchen paper was crumpled into a large ball and pressed onto an inky surface and then onto paper. Different effects can be achieved depending on the pressure used and how much ink is picked up by the kitchen paper.

Using solvent

A peep through a microscope might reveal an image similar to this one. It was made by dripping solvent (lighter fuel) onto a pattern drawn with felt-tip pens. A similar technique might be used to texture an area of foliage or water in a landscape drawing.

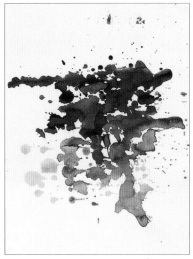

Random marks

Chinese ink diluted with water was dripped onto paper from the end of a paintbrush. The random collection of blots was then studied from different angles to see if anything came to mind. The artist realized that by adding a few brushstrokes here and there he could contrive a rocky coastal landscape. The inclusion of a boat on the left-hand side of the drawing successfully completed the blot-inspired picture.

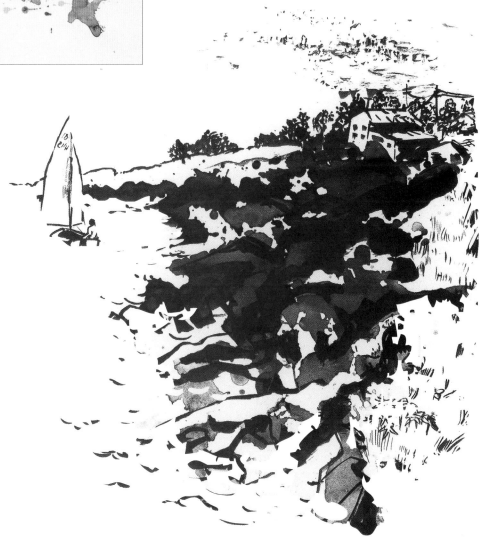

Stippling

This is a drawing or painting technique in which dots rather than lines form an image. Groups of small black dots placed closely together will read as a patch of grey tone from a distance. By altering the size and density of the dots it is possible to create a full tonal range. This method was often used in engravings to produce half-tones and very delicate lines, and the technique is still common in commercial illustrations, especially those in black and white. They are made with pencil or pen, the stylo-tip type pen being particularly suitable because it will produce very neat dots of equal size. Stippling does not have to be so mechanical, of course. Dots can be all shapes and sizes when made with the point of a brush or with a sharpened conté crayon, for example. Coloured stippling is useful as a texture-producing technique in which paint is applied in a dotted texture using stiff-haired brushes.

Felt-tip pens

These are ideal for stippling. A variety of tips are available and only gentle pressure is required to make the marks.

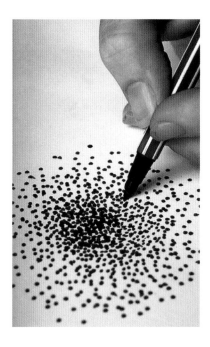

Dip pens

An old-fashioned dip pen produces beautifully varied dots and flecks when used for stippling. This takes rather longer than using felt-tip pens.

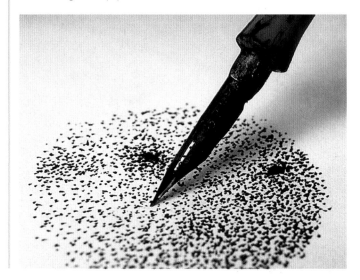

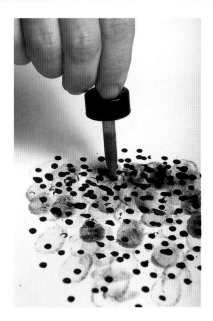

Combined methods

Here a layer of stippled marks has been made with a finger just moistened with brown ink, and black ink is now dropped over the top.

Finger marks

Inky fingerprints are very useful for producing unusual patches of textured stipple. Executed with coloured inks, this technique could be used to create foliage in a landscape drawing.

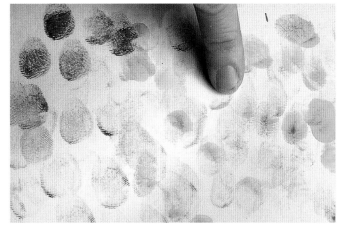

Dry-brush method

These stippled marks were produced by dipping a stiff housepainter's brush into ink and then partially drying it on tissue paper. There is still enough pigment left on the bristles to produce a stipple when the brush is pushed down onto the paper.

Pastel

Coloured pastel was used here to stipple three different colours together. A flat-sided and hard pastel produces irregular, angular marks.

Featured drawings

Building up texture

Controlled stippling with extremely fine black ink dots is capable of producing very subtle tonal gradations. The fur of this rabbit combines stippled dots with short, broken lines. Careful control of the density of the dots makes a range of pale grey tones on the inside of the ears.

All the images shown here are the work of professional natural-history illustrators, for whom stippling is an ideal technique, allowing for an amazing degree of detail. It is also perfect for suggesting texture, as can be seen in the drawing of the rabbit.

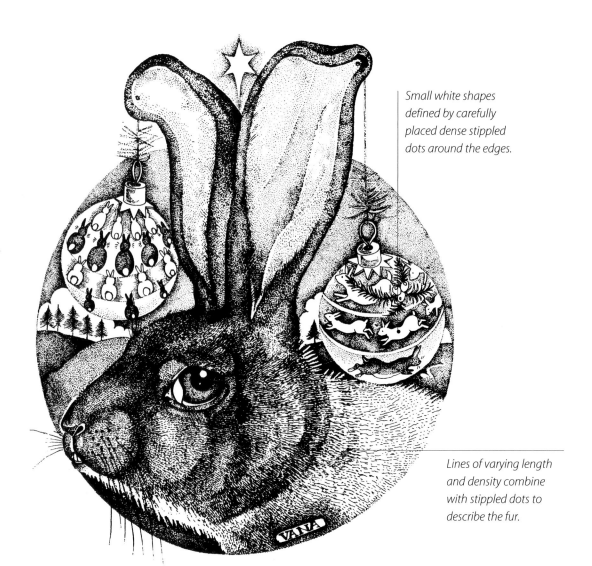

Small white shapes defined by carefully placed dense stippled dots around the edges.

Lines of varying length and density combine with stippled dots to describe the fur.

Reserving highlights

These two natural-history illustrations were drawn with black-ink stipple. Notice how, on the underside of the frog's mouth, the stippled dots link up to suggest the skin pattern. In the drawing of the beetle, the stipple has been carefully controlled, with the white of the paper left to show through as strong highlights on the shiny, black shell.

Tiny highlights reserved as white paper with solid black taken around them.

Highlights play a vital role in describing the hard, shiny texture.

TIPS FOR BEGINNERS

If you are trying the method for the first time, choose a relatively simple subject such as a single leaf or a small still-life object. You might find it helpful to work from a black and white photograph, which will simplify the tones to some extent. And if you find it impossible to reserve tiny white highlights such as those in the frog's eyes, you can paint them in afterwards with white gouache or acrylic, or opaque white ink.

Brush drawing

Working on crisp white paper with a good springy brush dipped in ink is one of the most sensual and expressive drawing techniques. The flowing lines, varied marks and capacity for rendering tone quickly and easily all contribute to its appeal. The boldest brush drawings are made entirely with a brush, without first mapping out the forms in pencil or pen. Fluid and decisive marks are the essence of a good brush drawing, but it takes a good deal of practice. Another approach is to sketch in the forms first with a brush and diluted ink or watercolour – so thinly that the marks can only just be seen. These guidelines can then be strengthened and built up more carefully by adding lines and washes of more concentrated ink where necessary.

Dry brush

For this method, the brush should be dipped in the paint or ink and then blotted on absorbent paper or rag to leave just enough ink to make a mark. The kind of mark depends on the brush used and the degree of moisture contained in it. In this example the artist has produced dry-brush lines that range from the almost imperceptible through to strong, bold lines, with the surface of the paper showing through the strokes to give a textured finish.

Expressive drawing

This study gives a lovely impression of life and movement, with the varied brushmarks describing the forms as well as adding interest to the drawing. Having established the main lines of the figure in watercolour, the artist indicated the hair, face and blouse using the same sable brush, which was washed carefully before the application of each new colour.

Varied brushmarks

A round sable brush produces many different marks depending on the angle at which it is held and the amount of pressure applied.

Different techniques

Again using a round sable brush, the artist has experimented with a number of different methods. Varying the pressure produces lines that can go from thick to thin in one continuous stroke. Blots of different shapes can be made in the same way, while an almost dry brush gives a broken effect.

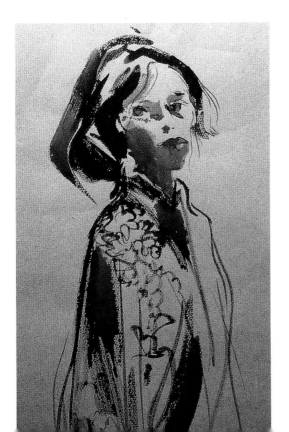

Line and wash

This is in effect a line-and-wash drawing (see page 70) made using a round sable brush and diluted ink. First the point of the brush was used to draw in the main lines of the dress and to establish the position of the head and the features on the face; more pressure was then applied to create shadow areas. Finally, additional details, including the pattern of the dress, were drawn using the point of the brush.

Line and wash

It is both interesting and constructive to try out combinations of media for your drawings, and one traditional combination that many contemporary artists still exploit is line and wash. The line might be produced with pencil or pen, and the wash is usually diluted ink or watercolour. The artist has at his fingertips all the flexibility and expressive potential that line can offer and the facility to effectively render tone, light and shade or colour rapidly with a wash.

The biggest problem with line-and-wash drawing is to achieve a unity between the two media. It is difficult to avoid producing a drawing which looks as if the tone has been merely added as an afterthought. The secret is to develop both line and tone together. You might begin by lightly sketching in shapes and contours with line and then lay in some tones with wash. Then, draw back into this with more decisive line work and strengthen the tones with bolder washes.

Chinese ink

Water-soluble Chinese ink was an appropriate choice for this delicate sketch of a rose. The flower was first drawn in outline and then washed over with clean water to dissolve and spread the ink and produce the subtle tones. Diluted ink was added for the darker tones on the stem and leaves. Once this was dry, crisper hatching and line drawing modified the shading and indicated details.

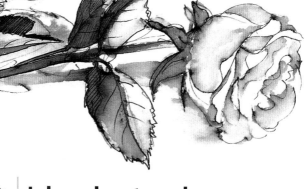

Ink and watercolour

Black ink and watercolour were combined to create this rapidly executed drawing. The first washes were added wet-in-wet to merge the tones together. Once the drawing had dried out, a dark wash was added to strengthen areas of shadow.

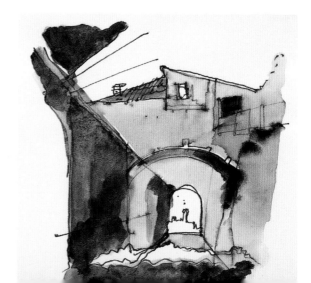

Using water-soluble pencils

1 These pencils make it possible to combine line and wash using only one implement. Make an outline drawing of your subject with firm lines and strong colours. The line needs to be quite heavy, since you will be using the pencil pigment to create the wash.

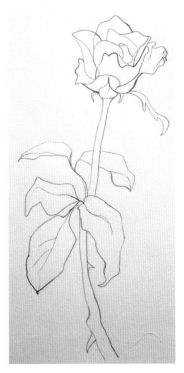

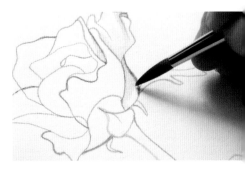

2 Moisten a fine sable or synthetic brush with clean water, and brush just inside the pencil line, picking up and spreading the colour into the shape.

3 At each stage of the drawing you can choose whether to strengthen the line work or deepen the washed colour. Be careful when working in water-soluble pencil over a wash, because the moisture softens the pencil tip and spreads the line.

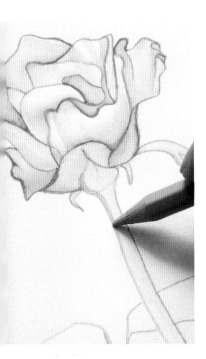

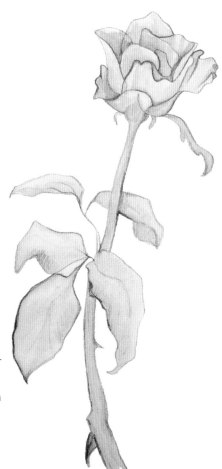

4 This approach to line-and-wash drawing produces a delicate colour effect, since the washed colour is relatively lightweight. To produce a dense, more graphic image, use paint washes.

Featured drawings

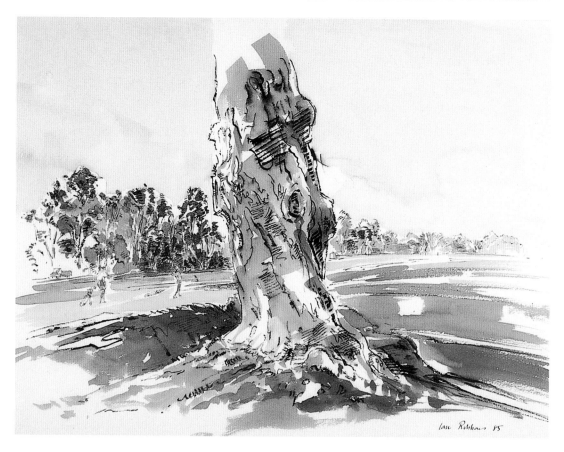

Nature studies

The flexible qualities of the nib pen, together with those of the brush, were combined to make this drawing. The foreground tree displays a variety of linear marks – fine outlines, hatching with broad strokes and calligraphic squiggles. Small dabs of watercolour make up the background foliage, and sweeping brushstrokes lay in the greens of the middle distance. The angular washes on the foreground tree have been made with a flat brush.

As you can see from the drawings on these pages, the line-and-wash technique is suitable for almost any subject and can be used in many different ways. It is especially good for quick sketches, since both line and tone (or colour) can be built up quickly.

Ink and watercolour

In these two lively drawings, completed very rapidly, brush and ink has been used rather than pen, but the effect is similar. In the sketch of the woman, coloured washes have been added over dry, water-soluble ink, which has spread and merged in places into the washes, most noticeably at the top of the head. In the drawing of the man, the washes have been added with the ink still wet. The merging of the two media is more unpredictable when worked wet-in-wet.

Working in monochrome

For this drawing, the artist has used water-soluble sepia ink combined with two art pens, which take cartridges of water-soluble black ink. To build up a range of tones, he has diluted the sepia ink with water and applied it with a brush over the black pen lines, which have spread into the washes to create soft effects. In the foreground, he has worked over the dry washes with more black ink.

Contour drawing

This technique takes advantage of the linear capabilities of graphite or coloured pencils to investigate three-dimensional form and volume. The planes and curves of solid forms are described in line only, using the outline of the subject and the contours within the overall shape to model the image.

A very economical line drawing can be highly expressive of form – the key is to be sensitive to the line qualities that best describe different elements of the subject. A variable line that swells and tapers, for instance, is more descriptive of curving contours than a line of even weight. Imagine tracing the actual surface of an object with your pencil, so that the pencil point travels easily over the form, but with varying pressure relating to the surface planes and undulations. The essence of a contour drawing is the same, but you are transferring these impressions to a flat surface.

Monochrome drawing

1 If you are using coloured pencil for contour drawing, it is best to choose a dark-toned colour rather than black, since the effect of, say, indigo blue or burnt umber is softer in mood. This drawing begins with the outline and main features of the seated figure.

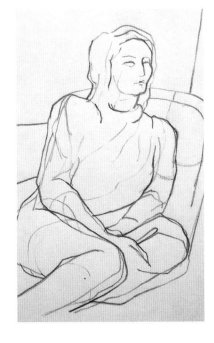

2 Although contour drawing is a minimal process, using only the linear cues in your subject, you don't have to get it all right first time. As you trace and retrace the contour lines that you see the 'correct' form will emerge. You can enhance the effect by adding weight to certain lines.

Linear framework

Leslie Taylor's drawing shows an interesting combination of contour drawing and subtle shading. Although the shading contributes a sense of volume through surface modelling, the viewer's 'reading' of the image depends strongly on the linear framework created by the contour lines.

Using local colour

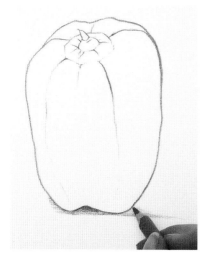

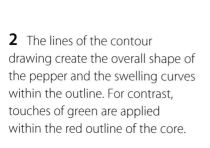

1 The advantage of using coloured pencils rather than graphite pencils is that you can often obtain a good effect by choosing a pencil corresponding to the local colour (actual colour) of the object. In this case, a warm red is chosen to try to match the skin colour of a red pepper.

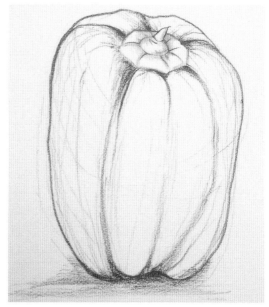

2 The lines of the contour drawing create the overall shape of the pepper and the swelling curves within the outline. For contrast, touches of green are applied within the red outline of the core.

Frottage

This technique is used in drawing to obtain textured effects. Its origin as a technique for making art is normally attributed to the German surrealist Max Ernst, who is reputed to have had the idea while staring at some scrubbed wooden floorboards. The prominent grain stood out like the lines in a drawing, and when he made a rubbing the inherent shapes within it inspired all kinds of images. By means of frottage, he transformed commonplace texture into drawing, full of fantastic creatures, unusual forms and foliage.

A frottage can be produced from almost any firm surface on which you can place your paper. Wooden boards, textured metal, meshes and fabrics like hessian give good results. Most dry media are suitable for making the rubbing and soft pencils or conté crayons are particularly effective. Frottage techniques can also be used in conjunction with pastels or coloured pencils to produce broken-colour effects.

Woodgrain

1 Paper is laid on the rough end-grain of a sawn tree trunk and shaded with a soft pencil to create a textured area.

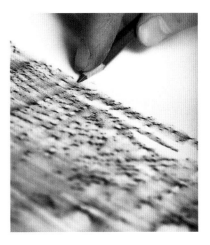

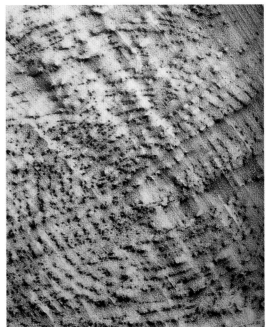

2 The growth rings of the tree are clearly visible in the completed pencil rubbing when viewed from a distance.

Textured metal

The artist produces a texture of dots and diagonals by using a piece of scene-painters' charcoal to draw over paper placed on textured metal. An area of broken colour is produced by the same technique, using coloured pastels.

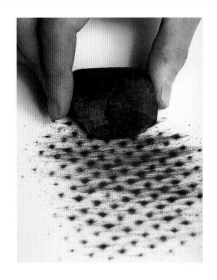

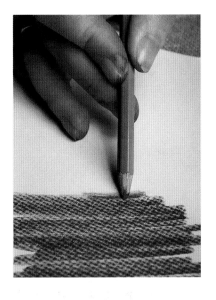

Fabric

A piece of hessian has been placed underneath this sheet of paper. As the artist draws across the paper with a coloured pencil, the texture of the fabric is revealed.

Textured glass

Window glass with a lumpy, 'pebble' texture produces an interestingly graphic network of colour. On the other side of the glass, the swellings and hollows are reversed and the frottage forms a kind of leopard-spot pattern. Two colours overlaid, using the front of the glass to give the texture, create a fluid, rippling pattern of interwoven lines that could form a pictorial equivalent for the surface of flowing water.

Sgraffito with coloured pencil

The technique of sgraffito involves scratching into a layer of colour to reveal the underlying surface. In effect, it is a 'negative' drawing process, since you create linear structures and surface textures by removing colour, rather than by applying it.

The method is commonly used with oil pastels (see page 80), but it can also be done with coloured pencils, as shown here. The process is the same for both media: first, you lay down a solid block of colour by shading heavily, and then apply a second layer of a different colour over the top, again built up solidly so that it uniformly covers the lower layer. The sgraffito drawing can be done with a stylus, or with the point or edge of a craft-knife blade. An alternative method is to colour the paper with a fluid medium such as watercolour, acrylic or ink and then shade over it with pencil in a contrasting colour. You could also apply a white gesso ground to the paper, working in a similar way to scraperboard (see page 82) to etch a white image through a dark colour.

1 Build up the pencil colours quite thickly and freely, using dense shading – the technique works best with soft, waxy pencils on fairly smooth-textured paper. Follow the general lines of your subject and the variations in the colour and shading.

2 Start 'drawing' into the colour with a sharp blade. Scratch the colour gently, taking care not to dig the blade into the paper surface. Faint lines are scratched back here to try to suggest the texture of the leek.

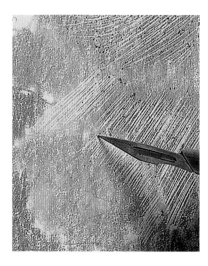

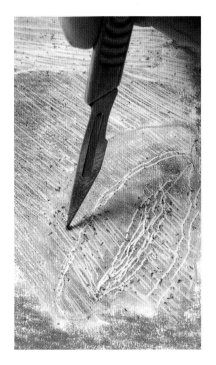

3 To emphasize contour lines and structural elements in the drawing, angle the blade to lift a thicker line of colour, revealing more white. You may find it easiest to turn the paper when tracing an irregular contour, rather than trying to manipulate the blade around awkward curves.

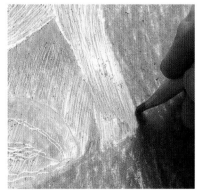

4 As the sgraffito drawing progresses, parts of the image are reworked with coloured pencils to give depth to the shadows and intensify the colours. You can also correct errors this way.

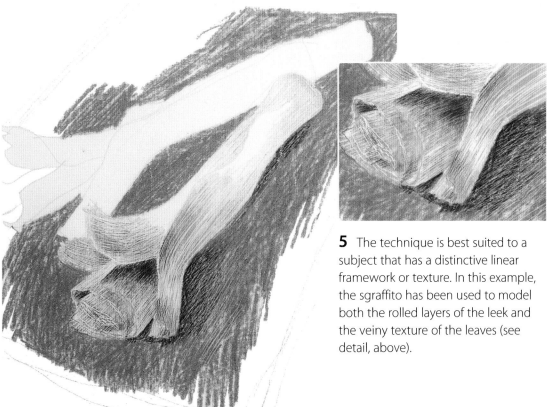

5 The technique is best suited to a subject that has a distinctive linear framework or texture. In this example, the sgraffito has been used to model both the rolled layers of the leek and the veiny texture of the leaves (see detail, above).

Sgraffito with oil pastel

The sgraffito technique is especially well suited to oil pastel, since the greasy medium is easy to scratch into and allows you to build up the solid underlayer of colour more quickly than you can with coloured pencils. Also, oil pastels can be 'melted' with turpentine or white sprit (see page 46), so the first colour can be laid on with a brush as a wash if preferred, but if you do this, make sure that the first colour is fully dry before laying on the second one or the two colours will mix. Don't use solvents for the second and any subsequent colours, since it will melt the first layer, and this must remain separate, sitting on top of the base colour.

Oil pastel over wash underlayer

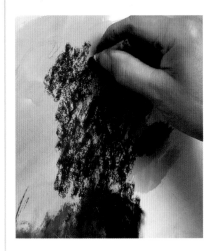

1 In this case, the base colour is painted with watercolour, but oil pastel mixed with spirit can also be used. When the 'wash' is dry, black oil pastel is shaded thickly over the surface and rubbed to produce a smooth, blended texture.

2 The drawing is begun with the tip of a craft-knife blade, taking care just to scratch back the oil-pastel colour and avoid digging into the paper surface.

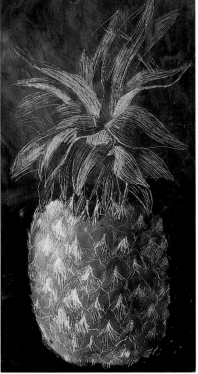

3 This example is worked as a line drawing, using closely hatched lines to produce the impression of variations of colour and tone.

Oil pastel over 'melted' underlayer

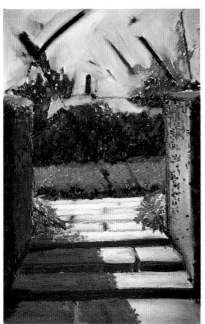

1 The artist has built up the image to a fairly advanced stage before starting the sgraffito. In the background, the colours have been spread and blended with white spirit (see page 46).

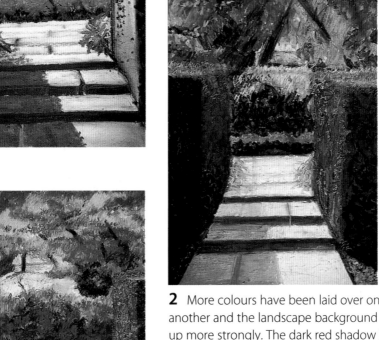

2 More colours have been laid over one another and the landscape background built up more strongly. The dark red shadow has been modified with overlays of paler colours. The point of a knife is used to scratch into the dark colours to reveal earlier layers.

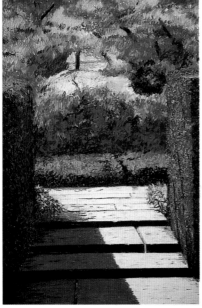

3 The intense purple-blue shadow has now been reinstated to provide a contrast to the sgraffito work on the clump of grass behind it.

Scraperboard

Scraperboard (or scratchboard) has always been very popular in commercial art, and is becoming more widely used by fine artists. It is a soft white board that can be easily marked with a sharp instrument. It is usually bought coated with black ink so that the sharp drawing tool cuts through the black surface to reveal the white underneath, but boards are also made with a white coating over a black base. Special tools are available that will produce fine lines or thick lines, but tools can often be improvised. The point of a pair of compasses makes a good drawing tool, and a scalpel or craft knife is useful for making broad marks and clearing large areas. Try using a broken saw blade for hatching or cross-hatching; in fact anything with which you can scratch or scrape is worth a try.

Broad lines

The point of the scalpel is used to make these chunky lines. The blade does not have to be razor sharp, so an older one is perfectly adequate.

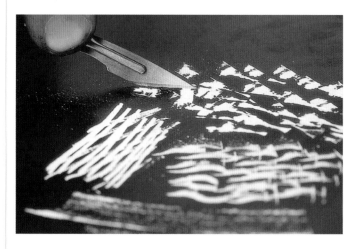

Fine lines

Almost any type of sharp steel point can be used as a stylus, so long as it travels easily across the board in any direction and produces a fine line.

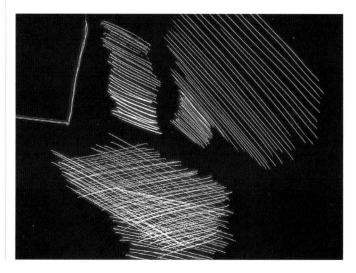

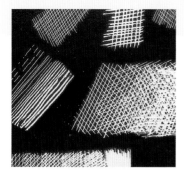

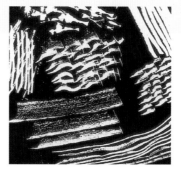

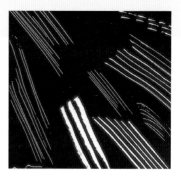

Drawing methods

Scraperboard can be likened to a negative pen drawing: white lines are produced, rather than black ones. And as with pen drawing, the techniques of hatching and cross-hatching (made here with lines of different width) are particularly suitable.

Varying the pressure

A collection of marks made with a scalpel. Where the blade has been drawn across the board quickly and lightly it has not removed all of the ink, producing a half-tone.

Thick and thin lines

Depending on the desired effect, the point or the edge of the scalpel blade can be utilized to produce a variety of broad lines and textural marks.

Pattern and texture

This design was produced for a cookery book, hence the chopping board of vegetables superimposed onto a landscape. The artist has exploited the decorative precision of the medium, juxtaposing different patterns to create tonal variation. Note how each facet of the small group of buildings is described with a different pattern. Around the design, the black-ink coating has been completely removed to form a halo of light that silhouettes and clarifies the composition.

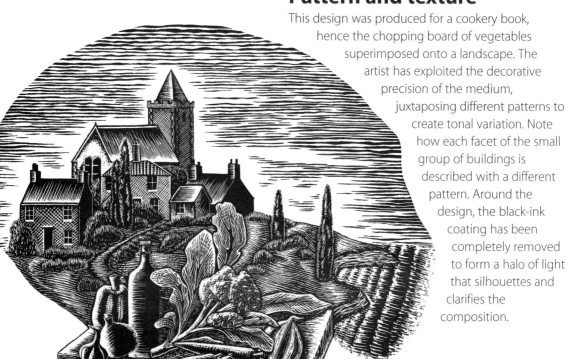

Scratching coloured pencil

Using an eraser to make corrections is a limited process in coloured-pencil drawing. Only lightweight strokes can be eradicated completely; a dense application typically leaves a colour 'stain' on the paper even after quite vigorous rubbing with an eraser, and heavy linear marks will also leave an impression on the paper surface that may show through subsequent re-workings.

An eraser may retrieve the surface enough to allow you to rework the area to modify tones and hues, but where you have a thick build-up of waxy colour, use the flat edge of an art-knife blade to scrape away the excess before using the eraser. Scraping is not only a correction method; it is also very useful for highlighting, and can achieve exciting linear effects in the sgraffito method (see page 78).

1 Eraser techniques can be used both for correction and as a positive drawing element. The outline of the dog is drawn on smooth paper. The detail shows where corrections have been made to the head.

2 The shape of the animal is roughly modelled overall, using light, warm brown and dark umber to shade in the basic tones and colours.

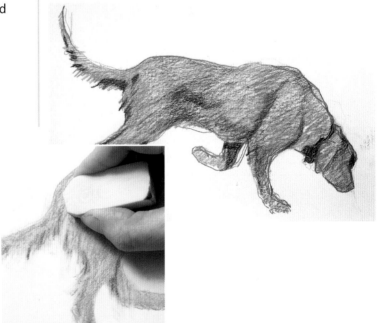

3 A plastic eraser is used at the contours of the animal's tail and underside to drag the colour outwards, making light feathered marks corresponding to the texture of the longer fur.

4 To brighten the highlight areas on the flanks and shoulders, the colour is scraped back with an art blade. This works best on smooth-surfaced paper, and you must keep the edge of the blade flat to avoid gouging the surface.

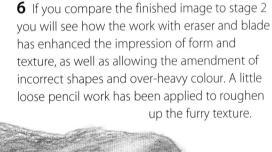

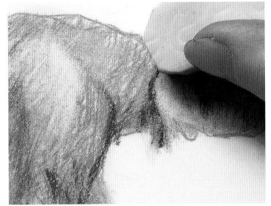

5 The plastic eraser is used again, this time for cleaning up the drawing and burnishing the highlight areas where the colour has already been scraped back.

6 If you compare the finished image to stage 2 you will see how the work with eraser and blade has enhanced the impression of form and texture, as well as allowing the amendment of incorrect shapes and over-heavy colour. A little loose pencil work has been applied to roughen up the furry texture.

Burnishing coloured pencil

The general definition of burnishing is applying friction and pressure to make a surface smooth or shiny. Burnishing with coloured pencils creates a glazed surface effect, compacting the colour and ironing out the grain. It can give the impression of colours being more smoothly blended, and increase the brightness and reflectivity of the surface. A commonly used method of burnishing is close shading with a white pencil over colours previously laid. You need to apply firm pressure, which physically compresses the underlying pigment and paper grain. The white overlay unifies colours and shading while also heightening the surface effect.

Alternatively, you can use a paler pencil, a neutral grey or one with a distinct hue of its own such as a light, cold blue or warm, pale ochre – but remember that the colour you choose will modify underlying hues, and you will lose any pure white highlights unless you leave them unburnished.

Dense, waxy coloured-pencil marks can also be burnished with a paper stump (see page 10) or a plastic eraser. This avoids the colour changes caused by overlaying a pale tint.

Describing texture

1 By overlaying areas of shading, the shapes of the hat and scarf are modelled in tone. A paper stump is used to burnish the colours, blending the shades to create softer gradations.

2 The light and shadow on the hat are enhanced by burnishing the highlight areas with a waxy white pencil. This merges the pencil marks, creating solid, pale greys.

3 In the final stages, the folds of the scarf are modelled by overlaying yellow over green, and white is applied in the same way as on the hat. Some loose drawing is then done with graphite pencil to create texture in the folds and fringe of the hat.

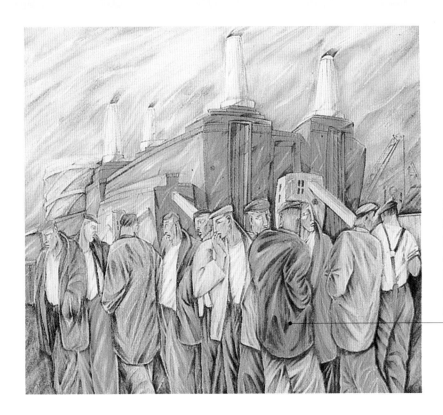

Stuart Robertson has used directional burnishing in his drawing Battersea Power Station *to capture the texture of the workers' clothing.*

EFFECTS OF BURNISHING

Burnishing with a coloured pencil compresses and polishes the first colour layer. The colour applied in the burnishing naturally affects the original hue. This example shows (left to right) an area of shading in waxy red pencil; the same colour burnished over with white; with blue-grey; and with light yellow; and the plain red burnished with a paper stump.

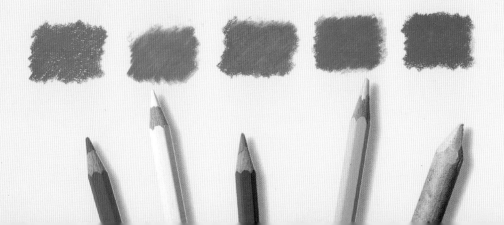

Masking

A mask is anything that protects the surface of your drawing and prevents a colour from being applied to a specific area. The simplest form of mask is a piece of paper laid on your drawing paper; the pencil can travel up to or over the edge of the paper, and when you lift the mask, the colour area has a clean, straight edge. You can obtain hard edges using cut paper; torn paper makes a softer edge quality. You can also use thin cardboard, or pre-cut plastic templates such as stencils and French curves.

If it is important to mask off a specific shape or outline, which may be irregular or intricate. You can use a low-tack transparent masking film that adheres to the paper while you work but lifts cleanly afterwards without tearing the surface. Lay a sheet of masking film over the whole image area and cut out the required shape with a craft knife. Carefully handled, the blade does not mark the paper beneath. Low-tack masking tape can also be used to outline shapes; it is available in a choice of widths, and the narrower ones are very flexible for masking curves.

Loose masking with coloured pencil

1 Place the paper mask on the drawing paper and hold it down firmly. Begin by shading lightly over the edges of the mask.

2 Build up the shaded colour to the required density, keeping the direction of the pencil marks consistent at each side of the mask.

3 Lift the corner of the mask to check that you have a clean edge and the right intensity of colour. Keep the lower edge of the mask in place so you can just drop it back if you need to re-work the colour area.

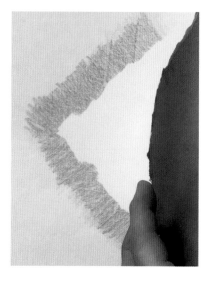

Masking with soft pastel

This abstract pattern shows the range of different textural effects you can obtain by working into and around masked shapes with pastels, varying the density of the strokes and overlapping colours one on another.

Stencil-type masks

Simple shapes cut out of pieces of paper form stencil-type masks that can be 'filled in' with different qualities of pastel colours to create relatively hard-edged shapes.

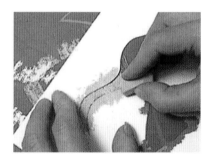

1 When applying colour within a masked shape, keep the direction of the pastel strokes consistent and work over the edges of the mask to ensure that the whole area is coloured.

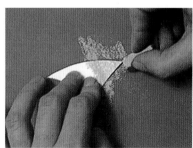

2 The cutout from inside the stencil can be used as a mask to form a negative of the original shape.

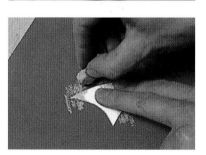

3 In order to keep the shading around the masked shape consistent, hold the mask down firmly while angling your fingers to gain access to the complete outline.

ARTIST'S TIP
Care must be taken when using masking tape, because if it is left on too long or is too sticky, it may damage the paper. If you cannot obtain low-tack tape, you can remove some of the glue by sticking the tape onto the back of your hand and pulling it off.

Impressing

The basic principle of impressing is that of making a mark that actually indents or grooves the surface of the paper. You can then work over it with gentle pencil shading (coloured pencil or graphite) which glides across the impressed mark so that it remains visible through the colour overlay. For a clean effect, the impressed line should be pushed down well below the paper surface, so place a newspaper beneath the drawing paper to allow some 'give' when you begin to apply pressure.

The impression can be made with a hard, pointed instrument that marks the paper firmly, but is not sharp enough to tear it. A blunted stylus or the wooden end of a paintbrush could be used, for instance. This means that the impression shows itself as the paper colour after you have shaded over it. Alternatively, you can make the same sort of 'blind' impression by working on tracing paper laid over the drawing paper, using a stylus, hard pencil or ballpoint pen to apply heavy pressure. The process of constructing a complex image in this way is shown on the following pages.

Blind impressing

1 Make your initial drawing on tracing or thin layout paper. Place a clean sheet of drawing paper on newspaper and lay the tracing over it. Retrace the outlines very firmly with a sharp pencil point or ballpoint pen.

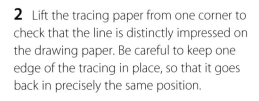

2 Lift the tracing paper from one corner to check that the line is distinctly impressed on the drawing paper. Be careful to keep one edge of the tracing in place, so that it goes back in precisely the same position.

3 When the impressing is complete, remove the tracing and put the paper on a drawing board or other suitable work surface. Shade colour over the impressed lines, using a light but even motion. You can blend or overlay colours in different areas of the drawing. Be careful not to apply so much pressure that the pencil tip is pushed into the white lines.

Blind impressing over colour

1 The basic method used here is exactly the same as blind impressing, but you work onto colour instead of on white paper. First create an area of even shading in one colour.

2 Use a trace drawing, as before, as the guideline for your impressing. Make sure you locate the image in the right position over the shaded colour.

3 Shade over the impression with a second colour, so that the first colour appears as line only. The overlay creates a subtle effect, but to read the line clearly, you need to choose colours with a good degree of contrast.

ARTIST'S TIP
If you want the impressed lines to appear in colour, you can either form them with the sharpened lead of a coloured pencil or you can put down an initial area of solid colour and make a blind impression on it before overlaying a second colour.

White-line drawing

This technique is a formal way of using impressing to create specific decorative effects in a drawing. You construct a detailed line drawing on tracing paper, then place it on your drawing paper and work over the lines firmly with a sharp pencil, stylus or ballpoint pen to impress them deeply into the paper. You can then build up the image by shading over it with soft graphite pencils, coloured pencils, hard pastels or pastel pencils.

The method provides an excellent means of reproducing specific patterns and textures, such as the fine lace in a curtain or tablecloth, or a delicate tracery of leaf veins. It can also be employed to form a 'negative' outline drawing, describing forms and volumes that can be filled with applied colours. The impression in the paper surface gives a kind of relief effect to the positive shapes.

1 Coloured pencil is used for this demonstration. An initial line drawing is made on tracing paper, using graphite pencil so that corrections can be made easily until the image is satisfactory. This drawing shows the contours of the frilly cabbage leaves and the lacy pattern of the veins.

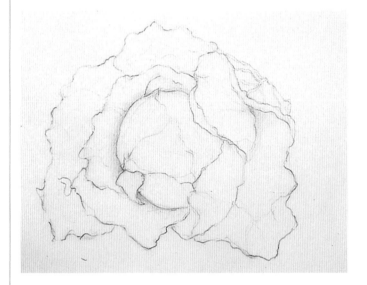

2 The keyline drawing is now positioned over the drawing paper, and a pencil is used to go over the outlines again, pressing hard to push the lines into the paper. A layer of newspaper placed beneath the drawing helps to provide a 'giving' surface.

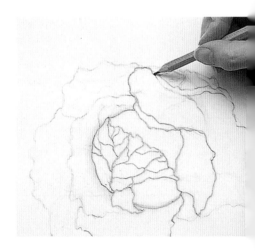

3 Turn back the top sheet to check whether the impression shows clearly on the drawing paper. Keep the keyline drawing accurately placed and retrace lines where necessary.

4 When the impressing is complete, remove the top sheet and start to work in colour on the drawing paper. Shade lightly over the impressed lines to reveal the image.

5 Gradually work over the specific areas of the drawing with different colours, developing the variations of colour and tone within the outlined shapes. Keep the layers of shading light, to avoid filling the white lines.

6 The completed drawing shows the structure and texture of the subject, with the folds of the cabbage leaves defined by dark shading. You can plan your drawing to include as much or as little detail as you wish.

Wet-brushing pastel

Because pastels contain very little except pure pigment they do not repel water as oil pastels do, and the pigment can be 'melted' and spread by brushing clean water over pastel strokes. This results in a grainy wash or loose mixture of line and wash. The granular texture of the pastel particles is retained, but their colour tints the water. If you wash over side strokes, for example, you obtain a dense and fairly even washed effect in which the pressure of the pastel on the textured support is still faintly visible. If, on the other hand, you lay down open-hatched or scribbled marks and brush over them very lightly, you retain the distinct linear pattern registered through a diffused, pale tint of the original colour. You can also effectively use this technique to create a subtle suggestion of tonal modeling in a line drawn in pastel—for instance, in figure work, to give a gentle shading to the main contours of the face and body.

Textured wash

Use a soft sable or synthetic brush to flood clean water over soft pastel. Light brushing will leave the grain of the pastel texture visible. If you move the brush outward from the pastel colour, the tinted water spreads a lighter tone over the paper.

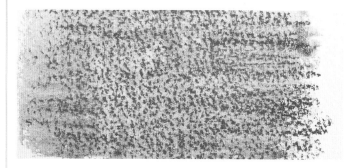

Line and wash

Hatched and scribbled lines stand out clearly against the paler tone of the wet-brushed colour. You can retain the strength of line because the water picks up the colour of the pigment but does not actually dissolve the pastel mark.

Modelling form

When describing an object, be careful to follow the areas of light and shadow that define the form in the initial pastel drawing, as well as applying local colour. As you wet the colour, brush it outwards from the heaviest tones and let it fade towards the highlight areas.

Combining wet and dry colour

1 In the first stage, a rapid impression of the subject is built up in soft pastel with loosely scribbled marks and rubbed textures.

2 Dark tones are added to give definition to the figure, both in describing the contours of the body and in emphasizing the dark mass of the hair.

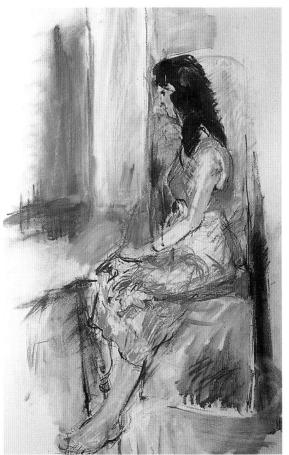

3 The colours are freely moistened with a wet brush, and the 'painted' quality of the image is gradually developed. Further pastel colour is worked into the damp surface, and finishing touches overlaid when the brushed colour has dried.

Coloured pencil on transparent paper

The use of a transparent drawing surface, such as draughting film or high-quality tracing paper, has been widely adopted by illustrators and has become a standard practice in coloured pencil drawing. The special characteristic of this method is that you can apply colour to both front and back of the transparent support, which increases the potential range and subtlety of colour mixing.

Draughting film is polyester sheet material, highly translucent, although it typically has a slight blue or grey cast that has a minimal influence on the applied colours. It is a very tough and stable medium, but comparatively expensive. You need a type that has a matt surface texture on both sides. If you prefer to use tracing paper, choose a type that is weighty and firm-textured: cheap, thin tracing paper becomes distorted by the pressure of the pencil and may easily tear.

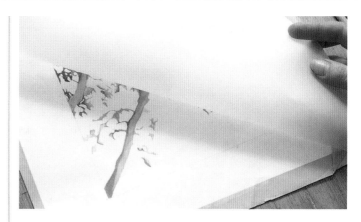

1 This example is drawn on a strong, smooth-grained tracing paper. The coloured-pencil drawing will be an interpretation of a monochrome watercolour study. The tracing paper is first taped down over the original.

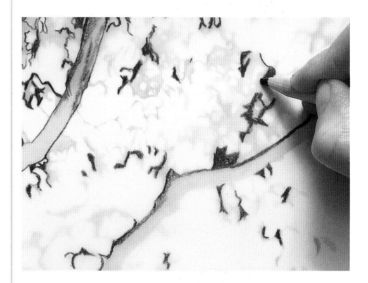

2 The darkest shades in the subject are drawn with a brown pencil. The drawing beneath is used as a guide, but it is not necessary to copy every detail precisely, since the pencil drawing should have its own character.

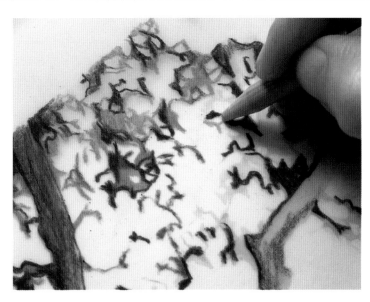

3 The decorative shapes of the tree trunks and leaves are developed using olive green and two shades of brown. This produces an effect similar to the original monochrome, but with livelier colour interaction.

4 This completes the first stage of drawing on the front of the tracing paper. The basic structure of the tree branches is fully established.

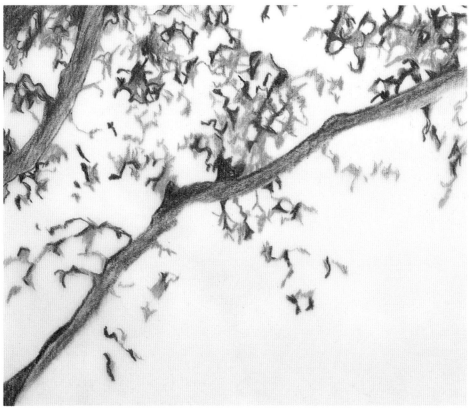

Continued on next page

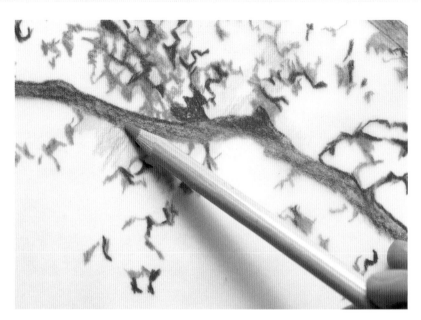

5 The lights and colours in the sky background are laid down on the back of the tracing paper. This enables the artist to work freely, without having to shade around the outlines of the existing shapes.

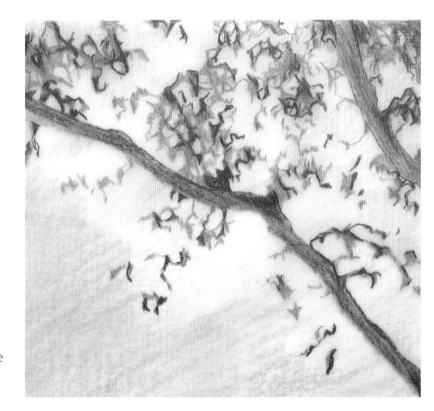

6 Gradually, the shading on the back of the paper is built up to cover the whole image area with delicate colours.

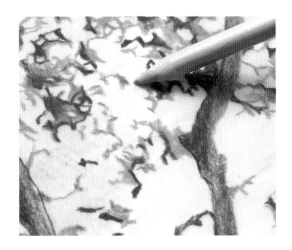

7 The drawing is turned over, and some additional sky colour is applied to the front of the paper, strengthening the tones and hues and helping to merge the light shades.

8 The process of separating the different colour ranges, so that pale tints on the back of the paper can be broadly blocked in without picking up colour from the darker shades, creates a good effect of bright light behind the trees.

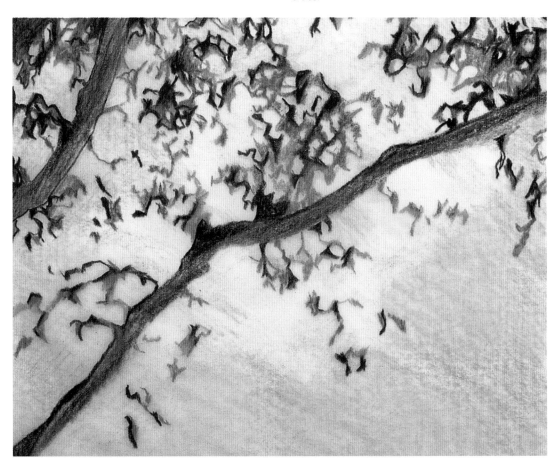

Markers with coloured pencil

This combination of media has been widely used in design and illustration for preparing presentation visuals and images for print. Its drawback for artwork intended to have long-term display potential is that some markers are not colour-fast, and colours may fade when exposed to normal lighting conditions over a period of time.

However, markers (see page 24) and coloured pencils make an attractive and versatile partnership: broad markers are often used to block in areas of solid and blended colour, with coloured pencil employed to impose a linear structure and fine-detail work. But since both can be used to create either line or mass, you can investigate different ways of putting them together to suit your drawing style.

1 There is a range of marker sizes, and here, broad ones have been used to block in an impression of three-dimensional form very rapidly. In this case, non-realistic colours are chosen, but the particular hues are selected to provide light, medium and dark shades for modelling the camera.

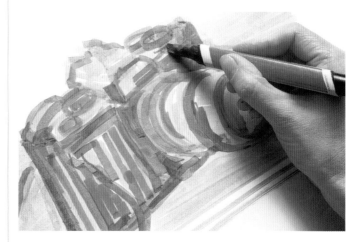

2 The marker drawing is reworked to increase the sense of solidity and suggest the shapes and textures of individual parts of the camera.

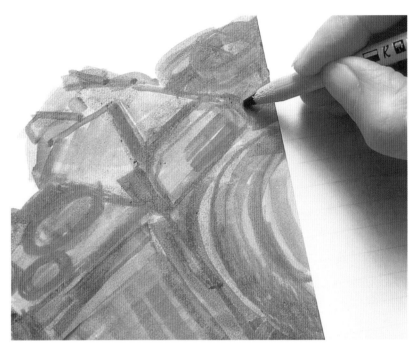

3 The coloured-pencil work begins with contour drawing in dark indigo blue in order to correct the outline shapes and give a firm structure to the drawing.

4 A black pencil is used to shade solid tonal blocks over the marker colour and to indicate surface textures and more precise contours.

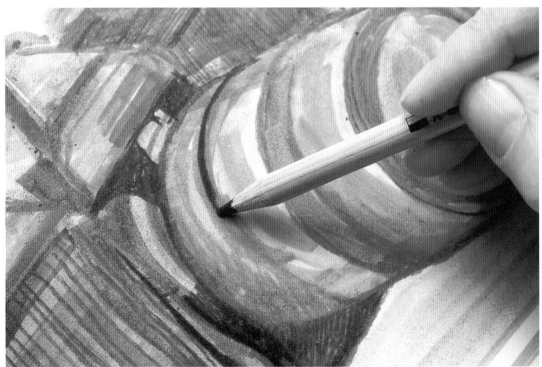

Continued on next page

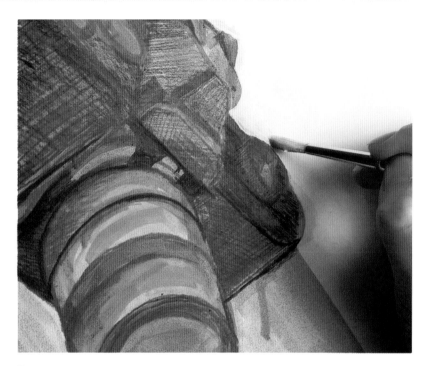

5 White gouache (opaque watercolour) is painted on to block out the shape of the camera against the background, covering stray touches of marker and pencil colour that were incorrectly applied. This is a useful way of amending a drawing in either medium. The gouache is not as clean and smooth as the white of the paper, but unless viewed at close range the corrections will not appear too obvious.

6 Where the colour has been built up densely on the camera lens, an art blade is used to scrape back the white highlight on the glass and outer rim.

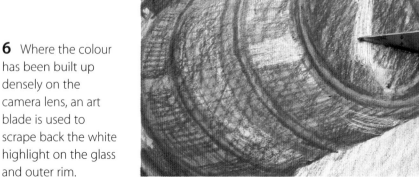

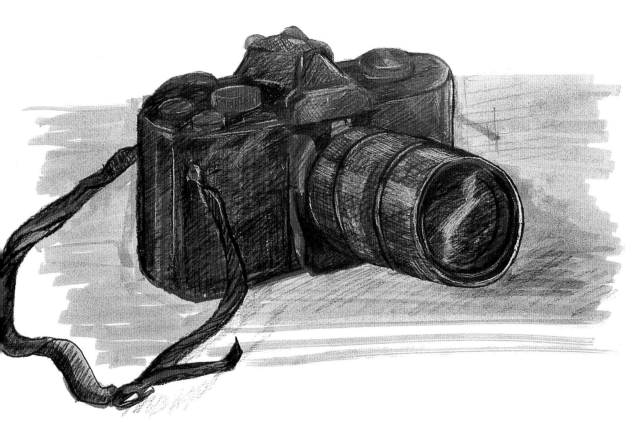

7 The finished image and detail (right) shows how the coloured pencil has been built up over the marker colour to define detail and enhance the weight and texture of the object.

Graphite with coloured pencil

Graphite pencils and coloured pencils are natural partners, since they are drawing tools of exactly the same shape that are handled in the same manner. Every artist finds different values in exploiting mixed-media techniques for particular purposes. A technical advantage of incorporating graphite with coloured pencils is the range in quality of graphite leads—you can obtain varied characteristics from the fine silvery greys of H and HB pencils to the increasingly strong, intense blacks of the softer B series (see page 10). Because graphite is a greasy substance, and more gritty than coloured-pencil leads, it gives a different kind of line quality, and the dark shades are not the same as those produced by coloured pencils containing black pigments.

1 When producing a drawing that integrates the graphite and coloured pencil textures, begin working with the graphite to set the linear framework and dark shades.

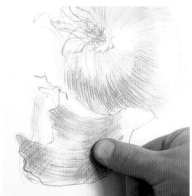

2 Soft graphite spreads easily when rubbed with the fingers. The method is used here to soften the shadow areas.

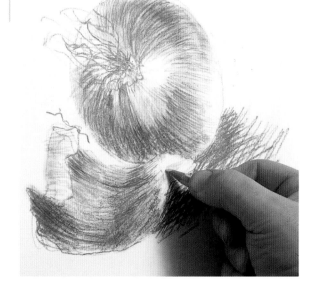

3 The basic colours on the onion are introduced with light shading and cross-hatching in yellow, yellow ochre and burnt sienna.

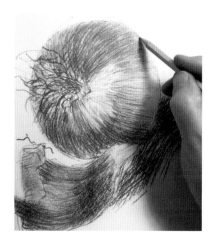

4 As the drawing progresses, further colours are applied to obtain the subtler hues and shadow colours. The textures of the graphite and coloured pencils are allowed to mix freely.

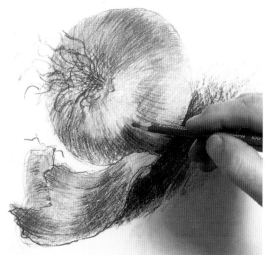

5 The colour is built up gradually to develop solid form. The graphite pencil is used again to sharpen some of the line detail in the drawing, enhancing the veined effect of the onion skin. The cast shadow has been strengthened with dark brown and grey shading.

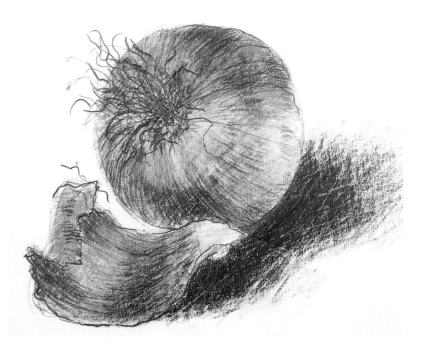

6 In the finished drawing, the graphite lines and shading describe the basic shapes, texture and dark shadow, while the coloured pencils contribute local colour and highlighting.

Pencil and pastel

However dexterous you become in manipulating pastels as drawing tools, it is difficult to sustain a hard, sharp line in this medium. Some subjects suggest a style of rendering in which linear qualities should be combined with a softer technique, and in such cases pencils can be a useful complement to pastel colours.

Choose relatively soft pencils, those graded from B to 6B (see page 10). In relation to pastels, of course, even these are fine, hard drawing points, yet they produce a subtle variety of line and grainy texture that complement pastel qualities. If you are using the pencil only for line work, you can work it into and over pastel colour, and vice versa. If you build up dense pencil shading or hatching, the slightly greasy texture of the graphite will resist an overlay of dry pastel particles.

1 The basic form of the animal is blocked in with soft pastel, using linear marks and broad colour areas rubbed in with the fingers.

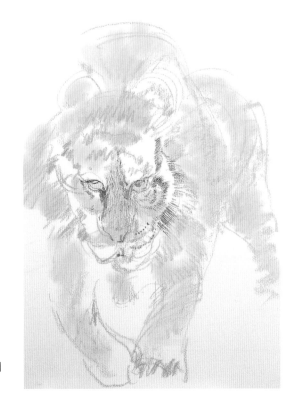

2 A furry texture is built up around the tiger's face with the lightweight, feathered strokes of a 2B pencil.

3 Pencil line is also used to sharpen the detail around the eyes and nose, working freely over the pastel colour.

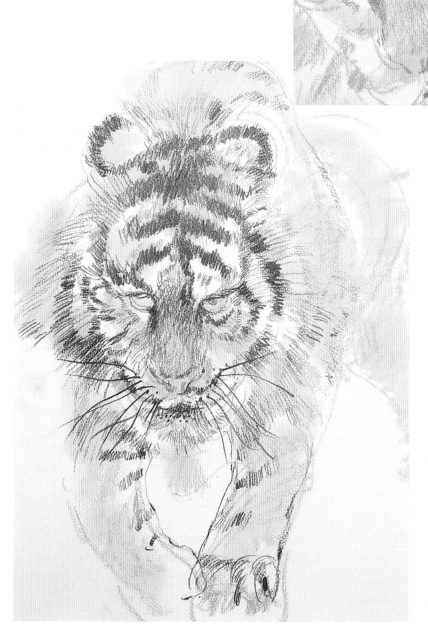

4 As the drawing develops, loose hatching and shading with the pencil builds up the stronger blacks of the tiger's stripes. Variations in the density of the pencil marks serve to create texture and tonal variation.

Resist techniques

Resist methods are based on the incompatibility of oil- and water-based mediums. If you lay down lines or patches of colour using an oil pastel, then brush over it with a thin wash of ink, watercolour or acrylic paint. The greasy texture of the pastel repels the fluid colour and the paint settles into the paper around the oil-pastel marks, leaving their colour and texture clearly visible. With repeated applications of both media, allowing the washes to dry in between, you can build up a dense, complex image.

A lightweight pastel stroke leaves parts of the paper grain unfilled, so the paint will settle into irregularities within the pastel colour, as well as around the edges. To get very distinctive, strong-coloured marks, you need to apply the pastel quite heavily. The best media for this technique, if you want to layer the image, are inks and liquid watercolours (those sold in bottles).

Basic resist method

1 Draw up the image in oil pastel, using heavy, boldly textured strokes. You can apply as many colours as you wish.

2 Apply a free wash of ink or watercolour, using a large, soft brush to flood the colour easily over the entire pastel drawing.

3 As you complete the wash, the liquid colour will settle into the paper grain within and around the pastel marks. You can use a single colour for the overlay, or several.

Scratching out

Some particularly dense drawing inks may flood the pastel marks rather than be repelled by them. If this occurs, you can use a knife blade to scratch back the ink when it is dry, retrieving the colour of the underlying image.

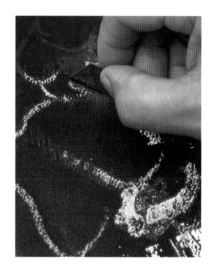

Layering the image

This resist image was built up in several stages with liquid watercolour over oil pastel. The textured pattern of the leaves was first drawn with white, pink and grey pastels, then loose washes of brown and green watercolour were overlaid. When the paint dried, parts of the pastel drawing were reworked, and further washes applied, adding blue and red to the colour range. This process was repeated once again to build up the density of colour and texture.

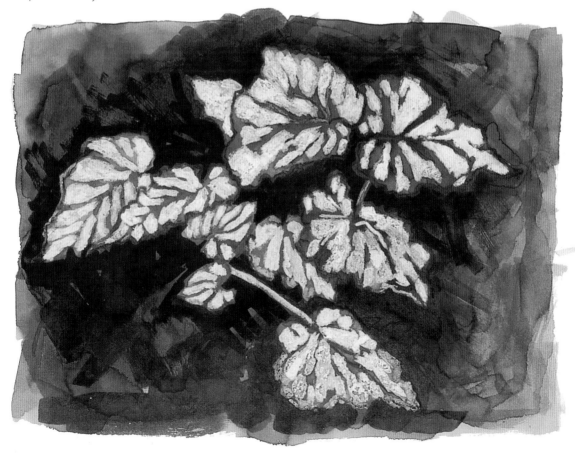

3
Subjects

Figure **Portraits**

A descriptive sense of character in a portrait is conveyed in the way you select and handle specific details. This does not mean that the style of your drawing has to be detailed and realistic – you can capture the essence of a person with a very simple contour if it is precisely seen and sensitively drawn. The character of the subject is expressed not only in the face but in particular poses or gestures, and you may choose to feature such aspects in your drawing. You can also use clothing and props that explain something about the person's lifestyle or occupation.

The subject's age is an important aspect of a character study, and there are various physical elements you can identify that suggest different stages of life, such as the angle of head and shoulders, the structure of the face and positioning of the features, and the colours and textures of skin and hair.

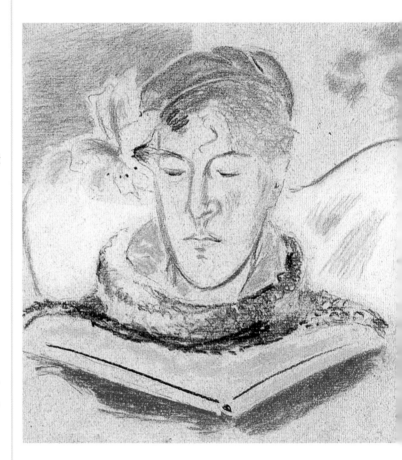

Descriptive details

Jeffrey Camp has used economical means to describe his subject in *Reader*, reducing the face to a few essential contour lines and adding the descriptive details of the hat, sweater and book as a way of enhancing the viewer's impression of the subject. The background colour of the paper gives the portrait a warm, sympathetic cast.

Essentials

In Linda Kitson's *Soldier* both the colours and the surface qualities of the drawing contribute to a good-natured portrait, capturing the particular shapes of the face and individual features in an expressive manner. The grainy lines of soft, waxy pencils are contrasted with solid areas of chalky colour and brief patches of watercolour wash.

The power of colour

The strong contrast of black and red, further enlivened by the complementary contrast of green shadow areas, presents a powerful, almost aggressive study of the face. The mood of John Townend's self-portrait is emphasized by the busy activity of the pencil marks, weaving over and around each other to describe form and texture.

Continued on next page

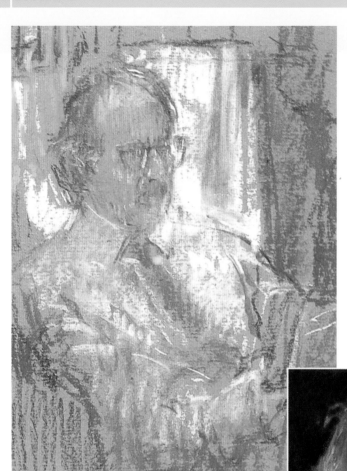

Informal portraits

The loose, open technique gives Tom Coates' *Seated Man* a sketch-like quality, but the visual cues are thoughtfully selected in order to create a characterful study. The warm tint of the coloured ground adds weight and depth to the entire composition.

Creating drama

▶ Ken Paine has created a strong feeling of drama in *The Gypsy* by working on black paper and incorporating strong light from the side. Although half the face is in shadow, the salient features, such as the nose, mouth and deep-set eyes, leave us in no doubt that this is an accurate portrayal of the subject.

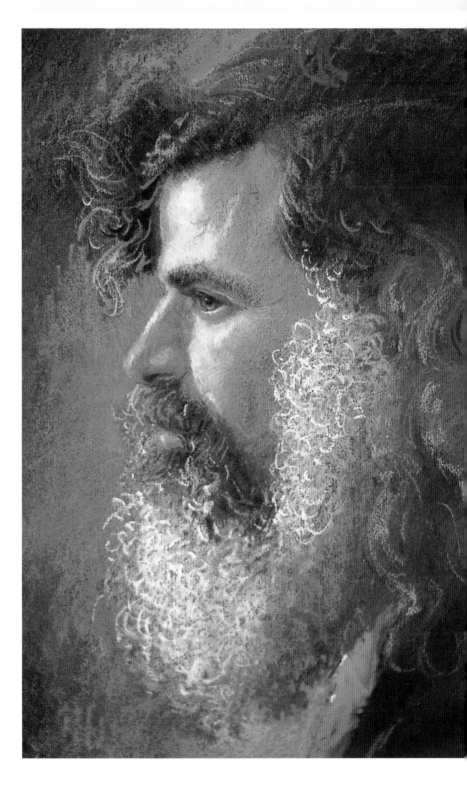

Facial hair

John Elliot's pastel drawing *The Artist* has a fascinating ambiguity: the eye is immediately drawn to the patriarchal white beard before registering that it is attached to a face not yet aged. In the beard and hair, the basic colours are loosely laid in with a form of scumbling, then developed with a complex pattern of brief, vigorous linear marks. In the face, the hatched and shaded colours are more closely integrated, giving the firm profile an imposing, sculptural quality.

Figure **Lighting for portraits**

Whether you are painting a head-and-shoulders portrait or a full figure, lighting is very important. You nearly always want to avoid a flat, face-on light, since this tends to flatten the forms, making the sitter look like a passport photograph. The most common form of lighting for portraiture and figure work is that known as three-quarter lighting, which, as the term implies, illuminates three-quarters of the face or body. In general, the light should not be too harsh, especially when drawing young women and children, but dramatic light can be effective for older subjects in some cases. For figure work rather than portraiture, backlighting can create exciting effects, silhouetting the body and creating dark, blurred flesh tones, but this is less suitable for portrait painting, where the features are much more important than the overall shape.

Side lighting

The main light source from the side in John Houser's *Big Wind* throws the subject's profile into strong relief, the clear-cut description of the features enhanced by the bold splash of brilliant red forming the background. All of the colour cues are strongly realized, allowing each pastel stroke a distinctive contribution to the development of form and texture.

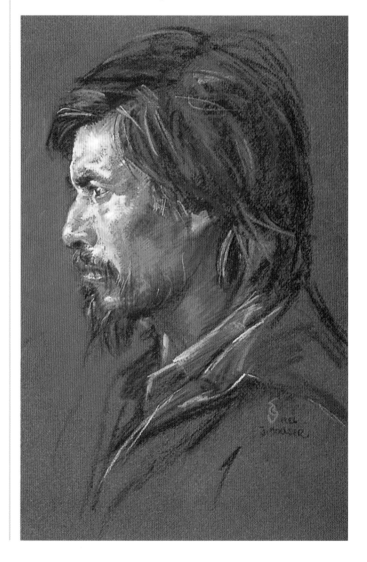

Monochrome studies

A monochrome study expresses the drama of the lighting. The technique seems very free and bold, but the interpretation in Ken Paine's *The Philanthropist* was carefully thought out. He has used soft pastel built up in thick layers to identify the particular structures within the overall shape of the head.

Continued on next page

Pastel on damp paper

The wonderfully atmospheric effect of this drawing *Self-Portrait in Repose* by Ken Paine was achieved by working soft brown pastel on heavy watercolour paper brushed with clean water. A strong sense of rhythm emerges from the combination of the pastel strokes and fluid wet brushing. The white highlights were added in the final stage.

Warm and cool colours

Ken Paine has chosen three-quarter lighting for his portrait *The Composer* in order to make the most of the facial features. Notice how he has created form not only through tone and linear definition but also through the balance of warm and cool colours, with brilliant, cold green and blue tints among the dark shadows; and strong, hot pinks developing the warmer lights.

Figure **Figures in action**

Most drawings of figures in action attempt to imply the action by freezing it at a particular, typical moment. The danger is that such freezing can produce a static result unless the movement before and after the represented action is implied in various ways. Sometimes, the free style of the drawing technique itself insinuates continued action, but more often it is the clever choice of the representative action that distils the whole movement to one frame.

The key to making action drawings is to observe closely and to draw quickly. The artist has to spot what is most important, commit it immediately to memory and then record it as soon as the movement has been completed. Practise by drawing people engaged in some activity that involves repeated movements and gestures, such as playing golf or serving at tennis. It is then possible to observe the action repeatedly and add to the drawing, rather than have only one chance to record it.

Looking for the essentials

Sketching in pen and ink, the artist has made a convincing study, but it is not until you examine the drawing carefully that you realize how much is only suggested. Yet everything is there, from the dark falling forelock, the bow tie and the shirt pulled in tightly at the waist, to the tight-lipped figure blowing in the characteristic way of woodwind players.

Rapid studies

Varied brushstrokes rendered in ink have quickly captured the essence of the dancer's pose, balance and the form of the torso and legs. The figure has great movement and tension because the artist has been able to quickly spot the contrast between the straightness of the arms and right leg compared with the curve of the back and left leg.

Brush drawing

The artist has employed a brush-drawing technique (see page 68) in this freely drawn sketch. An initial watercolour wash was laid down using a broad brush, and fine and medium lines were drawn with the point of a sable brush. Mid-tones were blocked in with two tones of ink, and the white gouache (opaque watercolour) was used for the highlights of cuff and collar.

Continued on next page

Line quality

Long, unbroken lines made in charcoal pencil admirably capture the stretching action of the figure and are complemented by touches of watercolour for the flesh and the dancer's garment to give the drawing a more life-like, three-dimensional feel.

Movement lines

This is a detailed study of dancers who posed in a particular position for the artist to draw. A strong but varied line in conté crayon (see page 16) describes the figures, with the muscular structure of the legs emphasized by the use of hatching and shading. Lines drawn when attempting to establish the correct position of the two bodies have been left around the figures, and act as movement lines and help to give an impression of two figures caught at a moment in time. Colour has been added in pastel to indicate the leotards.

Directional lines

In Ben Palli's *Weightlifter* it is the powerful direction of the pencil marks that gives expression to the actual movement of the subject. Although the artist can, in some ways, be free to put gestural rhythms into the drawing, he must also maintain strict control of the weight, thickness and extent of the marks in order to make the colours describe individual shapes and achieve tonal modelling.

Figure **Drawing the nude**

It was once believed that all figure drawing must begin with a study of the nude form, and although this is no longer seen as a must, it can be extremely helpful. Drawing clothed figures, for example, often involves some degree of guesswork, as clothing hides some of the forms and makes it hard to understand the position of the limbs and the vital angles, such as those of the shoulders and hips. If you have practised drawing nude figures you will be able to visualize the body beneath the clothing, giving your drawings more authenticity and confidence.

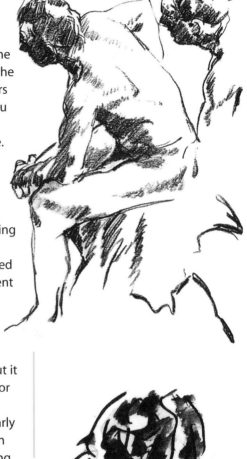

There are, of course, practical problems associated with this branch of drawing. Friends and neighbours may be willing to let you draw their portraits, indeed they may be flattered, but few are likely to offer to strip off, so you may have to enroll in a life-drawing class. Using photographic reference is not recommended because photographs will only show one viewpoint, and you need to be able to walk around and study a pose from different angles to understand it fully. Most people who attend these classes will vouch for their value, as well as to the enjoyment that can be gained from this most challenging of all subjects.

Any drawing medium can be used for life studies, but it is best to begin with a broad medium such as charcoal or graphite sticks (see pages 10 and 16) since these will prevent you from dwelling too much on detail in the early stages of a drawing. It is important to establish the main lines and shapes before filling in with shading or drawing facial features, fingers and toes, since these will often have to be changed if you discover the proportions are incorrect or that you have misunderstood the angle of the subject's head or hand.

Varying the lines

 In this study in black conté pencil the shadow side of the face and body have been shaded with hatching strokes, and a sense of solidity has been created by varying the strength of the outline and 'breaking' it in places. You very rarely see a single-strength contour line around a figure or any other object, because lighting conditions cause some edges to be 'lost,' merging into the background, while others are 'found', as with the knees and bottom of the thighs in this drawing.

Establishing the pose

◀ In this very rapid brush-and-ink drawing, the main directions of the figure are indicated with bold, sweeping strokes, reinforced with diluted ink in places to suggest form. Pen-and-ink and brush-and-ink are excellent for quick drawings, because the knowledge that you can't make corrections forces you to analyse the pose accurately before you begin.

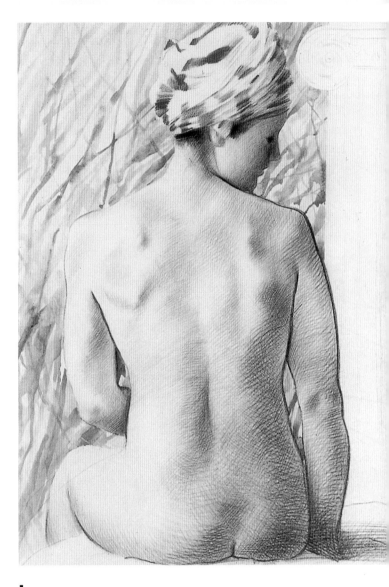

Long poses

The model was able to hold this pose for quite a long period, giving Adrian George sufficient time to achieve a detailed treatment in coloured pencil. *Turbanned Nude* has drawn inspiration from a painting by the early 19th-century French painter Ingres, which emphasizes smooth contours in a similar way. Notice the 'lost' edges on the left side of the figure, where the forms of the shoulder, arms and leg merge into the background.

Landscape **Seasons**

Perhaps the most appealing aspect of a landscape as a subject is that it is constantly changing. The seasons and the different weather conditions associated with them serve as an inexhaustible source of visual stimulation. Strong summer sunlight fills a landscape with colour and dark shadows, ideal for a colour treatment, while the same view when snowbound could provide a perfect subject for a monochrome brush drawing. Storms can transform a placid scene into an arena of contrast and dramas. Rain and wind create movements as they travel across a view, perhaps transforming a static leaf-laden tree into a dynamic feature yielding to the unseen force.

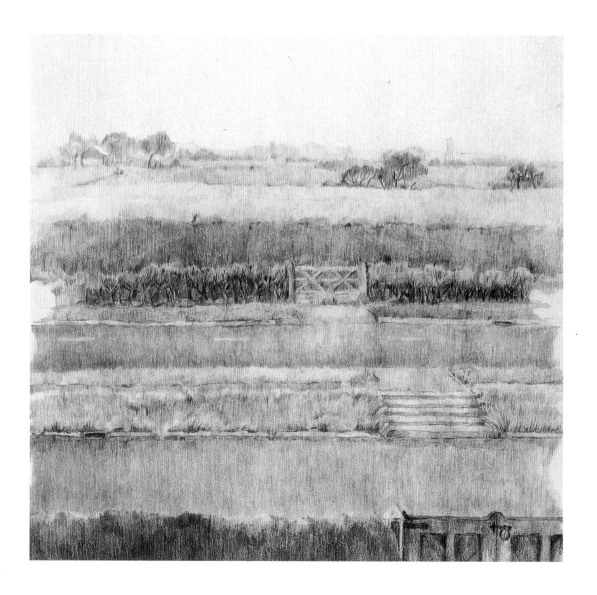

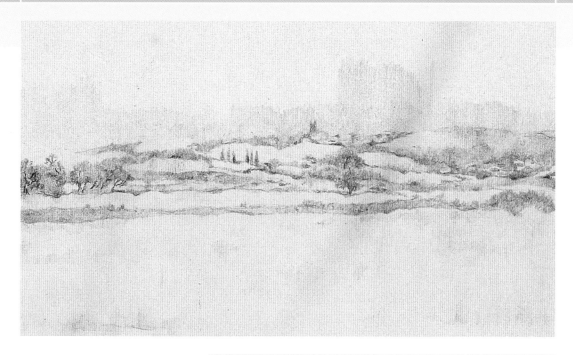

Recording the seasons

These three coloured-pencil studies by Moira Clinch explore the changes in the physical landscape as well as tonal variations. In the first drawing, the landscape is lit by strong sunlight, and the tonal contrast is high. In the second, the same scene is viewed in the subdued light of a dull winter's day and the contrast is reduced – notice also how the covering of snow changes the basic shape of the landscape. In the third drawing, the soft leafy hedgerow is captured in its bare wintry state.

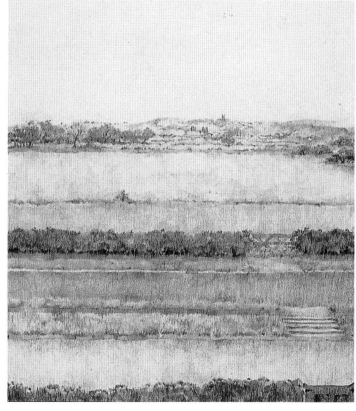

Continued on next page

First-hand experience

▼ 'Explosive' is one way to describe this sketchbook study, which was worked rapidly on the spot with pastels and inks. White wave crests on the choppy sea are expressed by allowing the white of the paper to show through the broken colour, and the lively, black calligraphic squiggles reinforce the sense of movement. To capture the effects of weather, it is best to work outdoors – immersed in it, since sound and the feel of cold winds are important elements in our experience and understanding of weather. Try to push the medium to its limits, as the artist has done here, so that the actual substance of the drawing reinforces the subject.

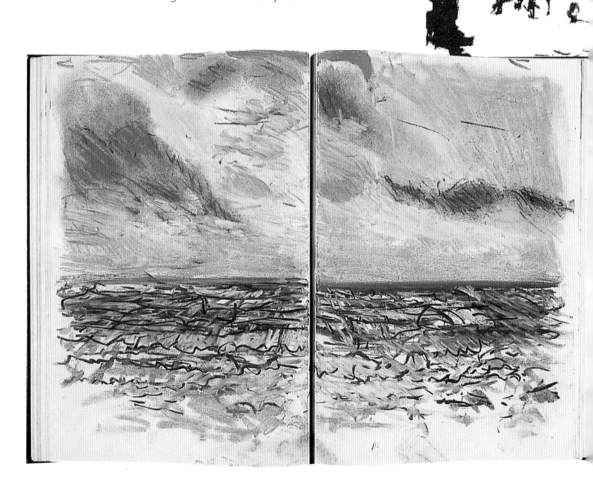

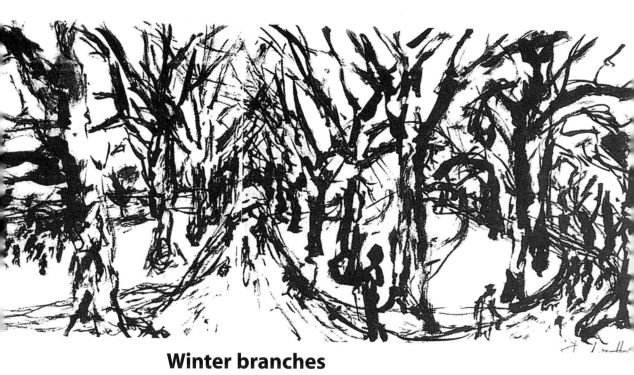

Winter branches

▲ Gestural drawing with brush and black Indian ink helped the artist explore the harsh, linear rhythms of leafless tree branches. The stark tracery of the tree forms and the agitated brushstrokes of the surrounding landscape convey a sense of cold, blustery weather, and the groups of small figures suggest a recent snowfall.

Pencil studies

▶ A stormy sea has been recorded by the same artist on another sketchbook page, but this time in pencil. Here the heavy sky is captured with strong vertical hatching, suggesting rain falling from a thunderous cloud as it races across the sky.

Landscape **Space and distance**

The pictorial space of a landscape is defined by your viewpoint – your position as spectator setting the level of the horizon line. The proportion of sky to land is significant in creating space, and the elements of landscape need to be carefully orchestrated to define spatial recession towards the horizon.

A relatively small area of the paper may represent a vast area of land, and you must achieve an accurate sense of scale, assessing the relationships of interlocking shapes and the way colour and textures are layered within the compressed space. Because coloured pencils are linear, careful judgement of the scale and direction of the marks you make is crucial to a convincing impression of space and distance.

Framing the image is an important factor. A horizontal format in itself helps to express the breadth of landscape and is more commonly used than a picture format with vertical emphasis. The overall shape of the image also affects the sense of space – the picture area need not be strictly rectangular – as does the extent of the view that you choose to include.

High horizon

A high horizon line leaves plenty of space to create a well-controlled progression from the foreground into the background, and in this pastel drawing the subtle variations in colour, tone and texture also help to draw the eye deeper into the picture. Notice how the length of the vertical hatching lines diminishes as it progresses up the paper, thus creating the impression of a receding plane.

Placing the focal point

In John Townend's coloured-pencil drawing *Copping Hall* the sweeping space of the landscape is achieved by locating the focal point of the building on the horizon line and emphasizing the curve in the foreground. Layers of loose shading create a rich impression of autumn colours.

Perspective effects

Linear perspective is the principal agent that creates a sense of space in the charcoal drawing. Converging towards a vanishing point, the compositional lines carry the eye towards the horizon. To bring the foreground forwards in space, the artist has reserved the strongest shadows and brightest highlights for objects closest to the viewer, such as the roller.

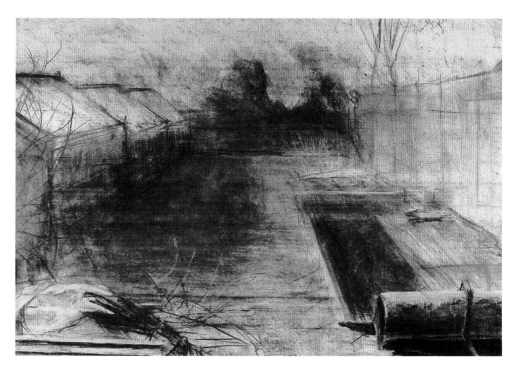

Continued on next page

Landscape is composed of shapes within shapes, from the broad levels of the land and any dominant features such as rocks and trees to the delicate details of foliage and flowers. Form and texture in a landscape image are developed out of concentration on the relative scale and complexity of these different elements.

However detailed your drawing, it is inevitably an approximation of what you actually see – no one draws every leaf or every blade of grass, and even the major forms acquire some modification as you translate them into a two-dimensional representation. The choices made in selecting particular aspects of the subject and working out ways of interpreting them technically are the ingredients of an artist's personal style. This selective process means that it is important to find those things that most effectively describe the character of the subject and convey your special interest in it, whether they are generalized forms or specific textures.

Foreground shapes

In Jo Dennis' coloured-pencil drawing, the wall forms a curving line leading the viewer right through the space of the picture and effectively cutting the composition into two parts. The focus on the large stones in the foreground startlingly enhances the perspective. These interlocked shapes contain an interesting pattern of smaller shapes within.

Compositional rhythm

In this coloured-pencil drawing by John Townend, each different element of the landscape is interpreted as contributing to an overall schematic rhythm, with individual forms defined by bold contour lines. The texture of the free shading is varied, as well as the colours, to help differentiate the hayfield from the trees flanking the far side.

Describing form through line

Although Carl Melegari has used an active, all-over texture of vigorous coloured-pencil line drawing in *Sydney Harbor Bridge*, he has contrived the colours in a way that allows distinctive forms to emerge from the busy surface. The texture of the image itself is as important as the structure it portrays.

Landscape **Trees**

Trees can either be viewed as part of the general population of a landscape or as special features for close study. They have a fascinating amount of variation in their natural shapes, textures and colours according to the characteristics of the individual species and the seasonal changes they undergo.

While botanical identification is not an essential feature of tree studies, it is important to pay attention to specific visual qualities such as typical outline, branch structure, leaf shape and colour. The more you analyse the particular qualities, the more you can develop the richness and detail of a tree 'portrait' or give definition and contrast to a study of massed trees.

Descriptive pastel marks

In pastel work, it is often advisable to give full rein to the intensity of colour, especially when the technique is free and bold. John Elliot has used oil pastel in his expressive study of trees in autumn to develop an active network of linear marks, where strong contrasts of colour and shading allow the form and texture of the foliage to emerge. A dark, heavily textured ground contributes to the broken-colour effects, although in places the pronounced grain of the paper is concealed by thick impasto dashes and streaks of colour.

The character of trees

Diana Armfield's *Aspens along the Path in the Rockies* conveys very precisely the character of the slender trees, and also demonstrates how the build-up of many small pastel strokes constructs the impression of form. The soft pastel is handled loosely and economically, blocking in areas of grainy colour and developing textural detail with a variety of linear marks. The cool hues dominant in the painting are offset with discreet accenting in pink.

Continued on next page

Seeing the mass

The majestic mass of this old waterside tree silhouetted by the pale sky in John Elliot's *Hudson River from Piermont Jetty* is boldly handled with a solid build-up of oil pastel.

Pattern and texture

John Elliot has used a form of home-made scraperboard (see page 82) for *At Audubon Lake*. This technique is very effective for a subject with pronounced qualities of pattern and texture.

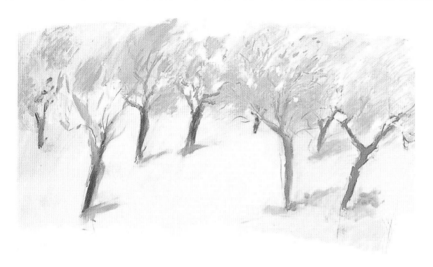

Interaction of shapes

A cultivated tree planting creates an interesting alignment of forms. Jane Strother's free oil-pastel sketch of olive trees focuses on the interaction of the angled trunks and foliage masses, eliminating incidental detail. The pastel is rubbed and blended to create basic colour areas, overlaid with linear marks and loose hatching and shading.

Individual methods

Debra Manifold has used an unusual variation of resist technique (see page 108) in this dramatic composition *The Retreat*. The image was first drawn in oil pastel, after which soft black pastel was vigorously worked over the oily base. As with the fluid media more often used in resists, the dry colour adheres irregularly and creates a tough, broken texture.

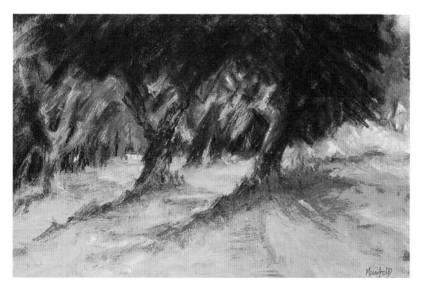

Tutorial **Space and light**

In this coloured-pencil demonstration, John Townend works towards achieving the particular sense of space and light inherent in his subject. The road leads into the distance, flanked by the solid shapes of trees, bushes and fences, and the unusual quality of light reflecting from the damp surface of the road creates unusual colours and shades in the sky at the central horizon.

1 The artist begins by drawing in the main guidelines of the landscape view with a soft pencil. These lines have a sketchy quality, creating the basic forms and rhythms of the composition.

2 Light shading is used to lay in broad areas of colour. In this initial stage of blocking in, varying intensities of yellow indicate the high tones, overlaid with a medium olive green to give depth.

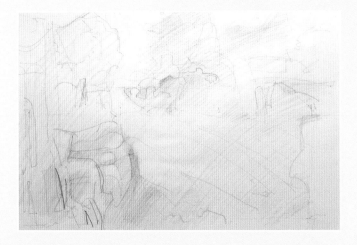

3 The whole drawing is lightly covered with free, open shading and hatching to 'knock back' the luminosity of the white paper and activate the drawing surface.

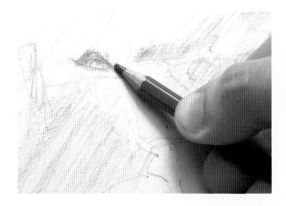

4 Colour variations are developed gradually by overlaying areas of shading and hatching. The artist begins to pick up some of the smaller and more detailed shapes and work into them.

5 This step completes the basic stages of blocking in to establish a definite structure to the composition and giving suggestions of individual forms and textures.

6 The drawing develops depth and texture through the overlaying of different colours and shades, but, as this detail shows, the pencil marks are still kept loose and open to avoid filling in the paper grain.

Continued on next page

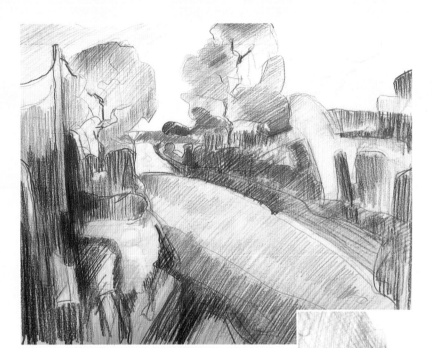

7 The definition of the overall composition is enhanced by laying areas of non-naturalistic colour, but the hues and shades are chosen to create a harmonious palette of colours equivalent to the effects seen in the features of the landscape.

8 Here, the pencil is held in an underhand grip in order to give emphasis to the linear marks that create the rhythms and directions of the landscape.

9 The surface sheen of the wet road needs to be represented by distinctive tonal variations. Colour blending and tonal gradation are built up with overlaid blocks of hatching in bold, strong colours.

John Townend

Autumn Road

In the final image, the artist has achieved the sense of space and receding forms and surfaces characteristic of this view, while attending to the abstract properties of shape and colour that give the drawing techniques an active presence in forming the image. In the final stages, he has used graphite pencil mixed in with the colours to strengthen the dark shades and redefine individual structures such as the tree trunks and branches.

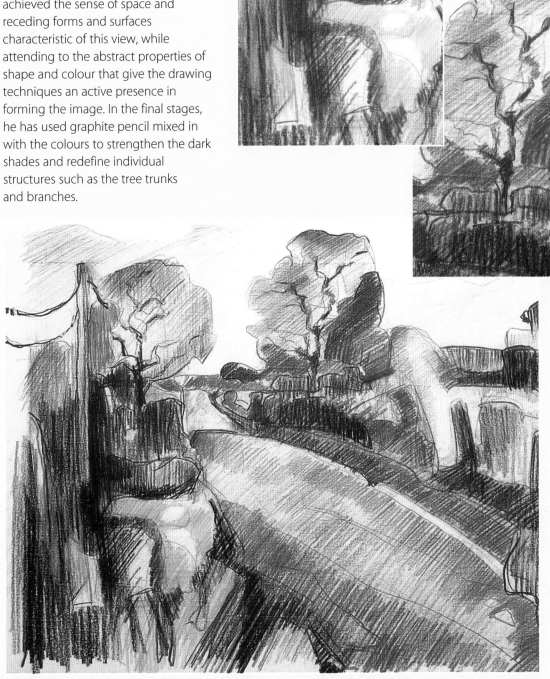

Urban subjects **Cityscapes**

Towns and villages provide a rich source of material for the artist. Walk down any street and you will find a wealth of shapes, patterns and textures that provide the raw material for exciting drawings. The precise shapes of buildings and rooftops afford the opportunity to create bold, geometrical compositions, or you might be more interested in recording the minutiae of urban decor; an old-fashioned lamp post, an open doorway or even an old stone fountain in a village square.

Whatever aspect of urban life you decide to draw, try to choose a medium and a technique that complements it. Do you want to record intricate details of a decorative façade, or express the noise and commotion of a modern city centre? For the former, you may decide on a linear medium such as pen and ink; for the latter you might try a bold mixed-media drawing.

Focusing on pattern

Coloured pencils were used to draw the intricate patterns of these timber-framed buildings. As well as recording surface details, the artist has used light and shade to create solidity and a sense of space. A drawing as complex as this one needs to be built up in stages, first establishing the general structure and then observing how the details relate to it.

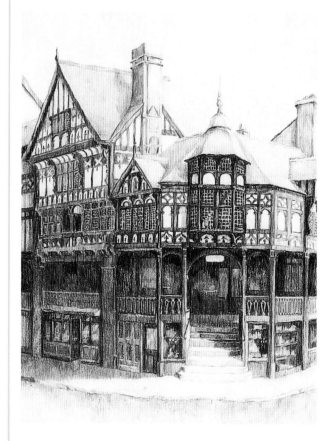

Emphasizing the centre of interest

▶ The church is the centre of interest in this drawing, and the artist cleverly leads the viewer's eye to it though the use of sharp perspective lines and the foreground figure walking away from us. The church is also rendered in more detail and contains stronger tones than the terrace cottages.

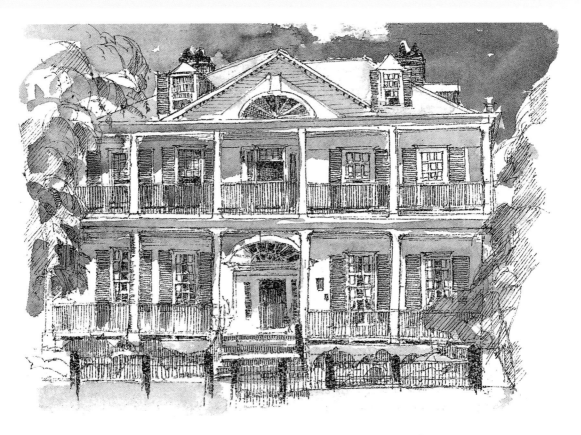

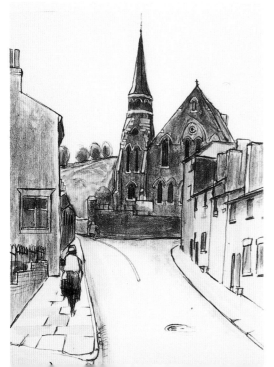

Pen and wash

▲ For this elegant building in the American colonial style, Jim Woods has used pen with ink washes, working on watercolour paper – which breaks up the pen marks slightly to give a softer effect. The image was built up in stages, starting with a very careful drawing to establish the main shapes, since proportions are vitally important for a subject like this. Detail was added gradually with the pen, and the washes were applied in the final stages. Notice that these are quite loose and free, giving the effect of dappled sunlight playing on the surfaces of the building.

Urban subjects **Individual buildings**

The spatial organization of individual buildings and architectural groups often provides a ready-made composition, with the colours and textures of the various construction materials adding surface interest. The colours and textures of pastels correspond well to features such as weathered brick, wood, stone and painted plasterwork. The medium's linear qualities also help to give definition to subjects composed of planes and angles.

A building often has a special character that makes it an attractive subject in itself. Its particular appeal can be stressed by the viewpoint that you take – distant or close, face-on or angled – with the building merging into or isolated from its surrounding context. The subject can also be enhanced by imaginative treatment of unusual effects of light and colour, as well as basic physical attributes of shape, form and texture.

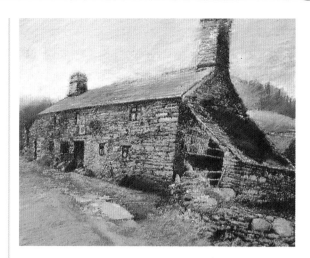

Choosing the viewpoint

The angled viewpoint chosen for Keith Bowen's *Ty Mawr* has allowed him to incorporate the whole of the interesting shape made by the old Welsh stone cottage. The drawing is in soft pastel, and has been worked on board rather than paper, giving a firm base to the build-up of overlaid pastel marks that describe the textures of the stonework.

Choosing the right paper colour

The bright sunlight on the awning was what first drew Margaret Glass' attention, and in *The Smokehouse, Cley*, she has placed it centrally in the composition. Because the colours are predominantly warm, she has chosen to work on an ochre-coloured ground, which shows through the broken colour describing stone and cobbles.

Tonal contrast

◄ The tonal balances in John Elliot's *Winter at High Point* supersede the colour interest, aptly translated with a limited palette of pastel earth colours on a warm buff-coloured ground. Controlled vertical and horizontal linear marks describe the planes of the wooden building, contrasted with the loose hatching and cross-hatching in ground and sky.

Continued on next page

Façades

Concentrating on the façade of a building is much like drawing a portrait. You have to work out which details convey the essence of the building's style and make it memorable. In Michael Bishop's coloured-pencil drawing *l'Escargot* the brickwork has been lightly suggested with a few faint lines in order to make the most of the lovely blue, contrasting with the strong blacks and the red bricks on either side.

Mixed-media drawing

In *King's Lynn* John Tookey has conveyed the formal structure of the townscape and its cool, greyed tones through an interesting combination of ink, line, watercolour and soft pastel. This has produced a varied but well-integrated range of surface qualities incorporating fluid and grainy textures, sharp linear detail and softer, atmospheric effects.

Controlled drawing

▶ This pen-and-ink drawing took an extremely long time to complete, and could not possibly have been created on the spot. By using carefully controlled horizontal and vertical hatching, the artist has successfully conveyed the texture of the bricks without needing to draw every one, and layers of cross-hatching have been used to create the very dark areas of shadow.

Urban subjects **Industrial settings**

There is typically a kind of harshness to an urban industrial setting or working environment. Such subjects do not immediately present themselves as sympathetic or attractive in the way that an open landscape might, yet they can be very inspiring, and often give a strong feeling of history. Working dockyards, factories, power stations, grain elevators and so on can be very inspiring subjects, removed from the normal run of flower paintings and lush landscapes, and allowing the artist to make comments about social conditions past and present. Much of the interest of such subjects lies in the unusual configuration of shapes and forms presented by the various structures that play a part in a particular function, for example buildings, machinery and vehicles. Linear frameworks and striking tonal contrasts are good material for either a monochrome or colour rendering, and some subjects have a stark, abstract quality that can be exploited in a semi-abstract manner.

Drama

To emphasize the sadness and drama of the derelict site, colours are limited to black and white with occasional punctuations of green and red. Debra Manifold's *Dockhead* is a rapid and spontaneous drawing using a combination of pastel, oil pastel and charcoal.

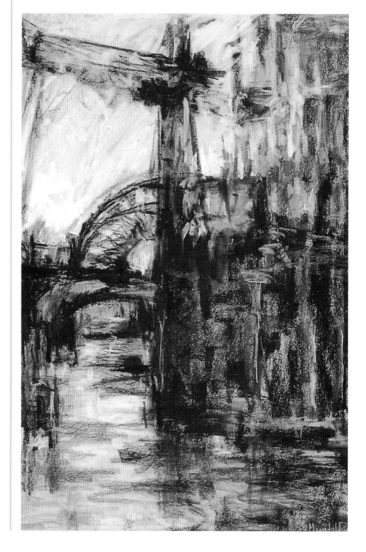

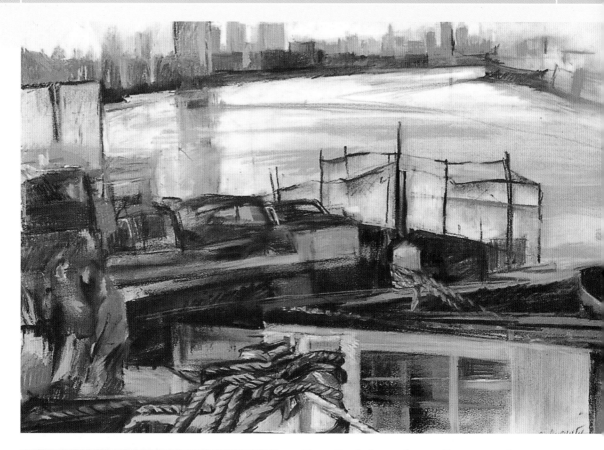

Exploiting hard pastel

▲ The texture of hard pastel is exploited in Pip Carpenter's *Wood Wharf Boatyard* to describe the geometry of the subject. The glassy surface of the river is represented with bold horizontal stokes of pure white.

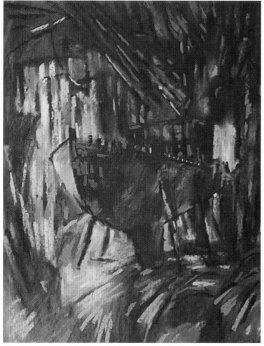

Light and shade

Geoff Marsters' *Interior of Boathouse* gives a marvellous impression of the dark, shadowy shed while still employing a lively colour range. The brilliant flashes of orange and blue enhance the spatial organization of shapes and volumes.

Still life **Groups**

The range of objects that can be used to make still-life groups is limitless. The choice might be deliberate or it may be almost accidental. You can choose related objects and place them together – for example a group of objects all relating to a particular interest or activity – or you can bring together objects that make an interesting group simply because of their complementing or contrasting sizes, shapes or colours. Some artists choose objects that either have symbolic qualities for them, or those that artfully exploit their technical skill.

Whatever kind of set-up you choose, still life allows you to build up your skills and try out ideas, and has always been valued by artists for these reasons. You can work at your own pace, both in arranging the group and in drawing it, and although the group may be affected by changing light it won't alter substantially. However, if light and shade effects are important – shadows, for example, can play important parts in a composition – it might be wise to take a photograph for reference purposes.

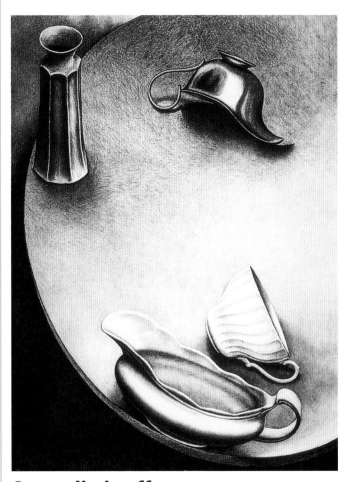

Surrealistic effects

A frequently used still-life method is that of placing an ordinary object in an unconventional way, thus creating a sense of surprise. In this pencil drawing, the feeling is enhanced by the realistic, almost photographic, drawing technique in which every shape and surface is clearly delineated.

Random groups

A random group of objects sometimes makes an arresting composition, purely because of contrasts in scale and shape. Here, the artist has used charcoal and conté crayon to create what is essentially an outline drawing, with some shading. The strong line and the sharp black areas make this a particularly lively drawing.

Decorative effects

This scraperboard drawing (see page 82) has a strong decorative quality, with the overlapping objects, described with broad, scratched strokes, seeming to jostle for position against a background of dense cross-hatching. Patches of solid black tone have been left to punctuate the surface pattern of the arrangement and also to add a sense of shadow and rounded form.

Continued on next page

Cropping

Pine cones grouped together in a bowl provide a challenging subject of complex forms and tonal patterns. In this carefully built-up pencil drawing, the artist deftly conveys the subtle variations in light and shade. A range of hatching and cross-hatching techniques produce a decorative setting for the foreground objects. Note how the artist has cropped off the bottom of the bowl to make a better composition and bring it forwards in space.

Familiar objects

Here, the artist has chosen a subject that obviously has personal associations. Jo Denis' *Sargent's Tools* has been worked in coloured pencil in a highly realistic style, with the conventional method of close shading used here to model the forms and textures tonally. Some delicate line work emphasizes the woodgrain patterns.

Working loosely

Tea Table is also in coloured pencil, but unlike Jo Denis (see opposite), Tess Stone works freely and loosely. All the objects in this group, in reality, have cleanly defined shapes and even textures, so the free technique and quirky contours provide an interesting reinterpretation that expresses the artist's own style and energy.

Still life **Fruits and vegetables**

All kinds of fruits and vegetables make ideal subjects for still life, whether you are working in colour or monochrome. The shapes are distinct and self-contained, the colours bright and appealing, and the variable textures suggest interesting ideas for visual interpretation. Individual items are easily available and mostly inexpensive, and will last well if you need to leave a still life in place so that you can complete a drawing over a period of days.

These simple, natural forms are excellent vehicles for learning and practising drawing techniques – you can find a great deal to study in just one or two common fruits, such as apples or oranges, or a vegetable such as a pepper, aubergine or a cut cabbage. To create greater complexity in the image as your confidence builds, you can construct a more ambitious still-life group, perhaps adding fabrics, ceramics or glass items – such as a bowl in which to hold fruit – to extend the variety of form and texture.

Limiting the shapes

Part of the effectiveness of Barbara Edidin's composition *Vicky* lies in confining the still-life aspect to the simple, similar shapes of the apples, rather than selecting very different fruits. The artist concentrates on reproducing their colours and textures very precisely and applies the same sharp vision to the qualities of the fabrics. The drawing shows the intensity of colours and tone that can be achieved with coloured pencil.

Tonal patterns

In this pen-and-ink drawing, hatching, cross-hatching and free shading describe the patterns of light and dark on the surface of the fruit, linking the objects together and effectively camouflaging them. Bracelet shading emphasizes the roundness of the forms, but it is not allowed to create too much of a three-dimensional effect. The dominant feature of the selected group is the interplay of the patterns formed by the objects and the shadows around them, which has been given greater importance than the plasticity of the fruit.

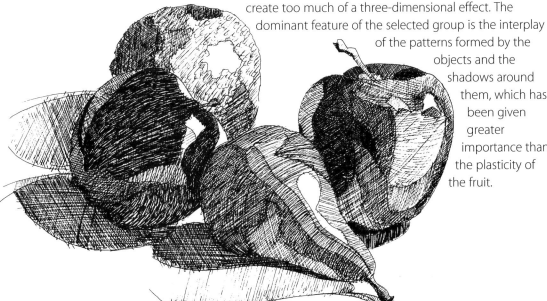

Surface texture

This unpretentiously attractive subject is interpreted by Sara Hayward with a vigorous approach to the coloured-pencil drawing technique. The combination of hatched and shaded colour creates an open surface texture that allows the colours to sing out clearly. Notice that the heavy shadow areas are also treated colourfully.

Still life **Found objects**

Frequently, the best still-life subjects are found rather than contrived. A few children's toys dropped by chance in a corner, or the kitchen table after a meal has been eaten, with knives and plates scattered at random, can make unusual subjects out of everyday situations. The disadvantage of the found subject, however, is that often it is impossible to keep it frozen in position for long. The still-life drawing has to be made quickly before the toys are played with again or the table cleared.

There are excellent still-life subjects outside as well as indoors. The corner of a greenhouse with gardening tools and plant pots, junk in a scrap yard or agricultural implements in a farmyard could all serve as interesting still-life groups. But, again, sometimes a really exciting subject only remains composed long enough for you to make a very rapid sketch – a pile of deckchairs on a promenade, for example. On other occasions something seen by chance can suggest a still-life group that you may deliberately set up in a more convenient place.

Seizing opportunities

Speed was the essence of this strong, vigorous drawing of a table lamp and other objects left on a kitchen table. Using a brush and black ink, the artist has exploited the dark mass of the objects silhouetted against the light, shiny surface of the table. The ink has been applied undiluted except for some light shading on the background plate and the table surface.

Everyday subjects

◀ Look around you and you will see potential still-life subjects everywhere. Unmade beds are one example, and the artist has exploited this found group to great advantage in this coloured-pencil drawing. The mass of stripes and folds creates a lively and attractive image, and the artist has expanded on the theme by including the clean, vertical stripes of a radiator in the background.

Still life **Household objects**

There is a great deal of material for detailed study in everyday objects found all around your home. Furniture and clothing, which have been chosen originally for the interest and attractiveness of their shapes, patterns and textures, make excellent subjects for drawings. A chair, a rug, a coat hanging up or a pair of shoes sitting on the floor – such apparently simple, familiar items – contain a wealth of detail and teach you how to analyse basic shapes and forms as well as specific surface qualities.

Many smaller items can be found that contribute to colourful still-life groups, enabling you to make close-up studies of form and texture. As shown here, simple items from a sewing basket make a fascinating image; other good possibilities are kitchen implements, cosmetics and toiletries, ornaments on a shelf, or the materials and equipment found on a desk or studio table.

Composition

Sara Hayward's coloured-pencil drawing *Slippers*, is a simple but very carefully thought-out composition, with the slippers placed at an angle on the fabric, and the linear marks of the floorboards echoing the patterns on the objects.

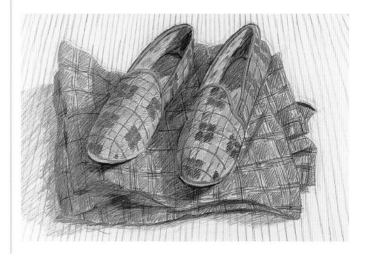

Rhythm and movement

In *Chair*, Sara Hayward has used a combination of watercolour and coloured pencil, and the pencil marks are actively drawn, contributing rhythm and energy to an otherwise static subject.

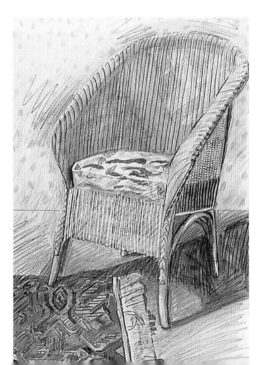

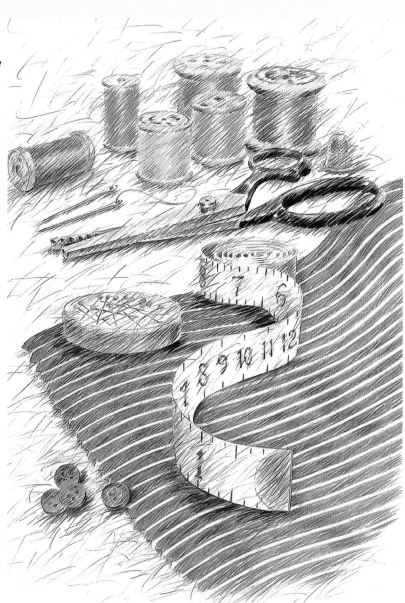

Tools of the trade

▲ Jean Ann O'Neill's image is a witty reference to the medium she uses for the drawing, and is attractively interpreted with shading and erased highlights.

Small objects

In *Sewing Materials* the jewel-bright colours of the spools of thread make a vivid contrast to the restrained pattern of the striped fabric. The bright hues are nicely echoed in the reflections on the scissors and pins. Carl Melegari's characteristic style of vigorously woven coloured-pencil marks is cleverly adapted to the scale of the objects, even encompassing detail as graphic and precise as the numbers on the measuring tape.

Tutorial **Still life**

The luscious textures of cakes and fruit inspire a free, inventive way of working in pastel that combines a range of active techniques. The artist creates a vivid interplay of hues and tones within a strongly descriptive image.

1 A textured ground is applied by brushing PVA (an adhesive acrylic medium) over stretched watercolour paper and rubbing in ground chalk (whiting) and raw umber pigment. The basic shapes of the still life are roughly sketched in white pastel and the ground is reworked with a brush.

2 The outline sketch is developed in more detail, using sepia and light mauve to emphasize contours and suggest shadow tones, and pale tints to heighten individual shapes against the mid-toned background. By wet brushing (see page 94) over an application of soft yellow pastel, the artist models the solid volumes of the fruit.

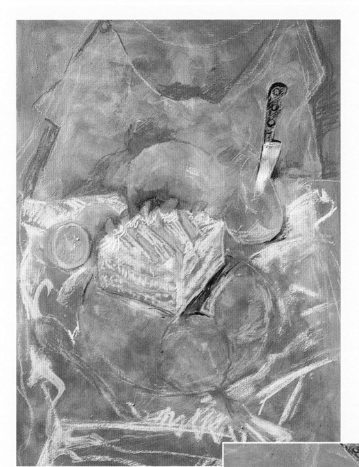

3 Working rapidly with a combination of linear marks and wet brushing, the artist blocks in several items of the still life more definitely. At this stage, the range of colours remains limited, and the drawing process is concentrated on developing form and texture.

4 The palette is gradually extended by reference to local colours and the patterns of light and shade that model the forms. The colours are loosely blended by finger rubbing, maintaining an active surface effect.

Continued on next page

5 Before continuing work on the central section of the image, the artist indicates the surrounding colours, laying in the strong white of the tablecloth more broadly, and indicating the warm red of the strawberry tart. She then returns to details of the fruit and cake.

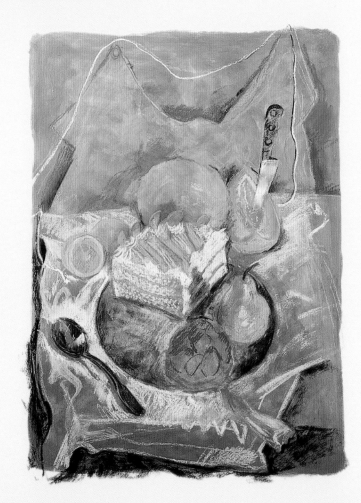

6 The image is now quite strongly established, but there is a lot of detail work to complete. The full range of tonal variations is in place but the forms and colours need to be built up with greater complexity.

7 As each component of the still life takes solid form, the artist works freely all over the image, adding highlights and colour accents and strengthening the shadow areas. Dry pastel work is again combined with wet brushing to enhance the range of textures in the final image.

Rosalind Cuthbert
The Feast
This is a 'high-key' work, with no very dark tones. All the colours are unified by the warm-coloured background that shows through the pastel strokes to a greater or lesser degree all over the drawing.

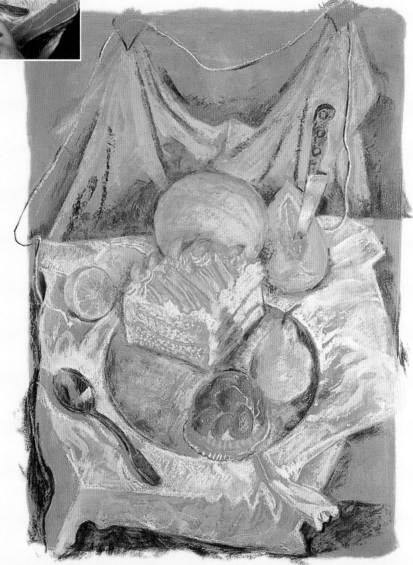

Nature **Animal sketches**

Quick sketches are an invaluable method of getting to know animal forms, and after a little practice you will find that you can respond very quickly to the movements of the subject. Often, a single continuous line in pencil, charcoal or pastel can catch the perfect impression of a graceful animal contour. Sketching also sidesteps the problem of having insufficient time to study the animal effectively, because your representations can be a series of rapid drawings, or you can have several sketches on the go and return to the appropriate one according to what the animal is doing at any given time. Domestic and zoo animals develop routine movements and cycles of behaviour, so that you can count on an individual pose or movement recurring. With patience you will begin to recognize the elements that are essential to your representation, and develop effective ways of interpreting them in pastel.

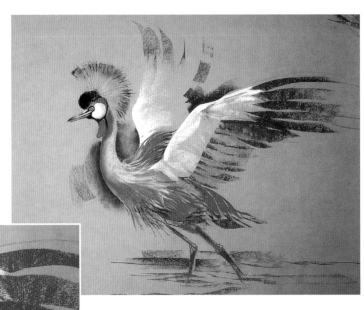

Pastel marks

Different types of pastel marks can be matched to the range of textures in an animal or bird. In John Barber's pastel sketch, broad side strokes have been used to define the sweeping shapes of body and wings, fine linear marks for the crest and smaller body feathers and gentle blending to imitate the soft sheen of the downy plumage on the bird's neck and breast.

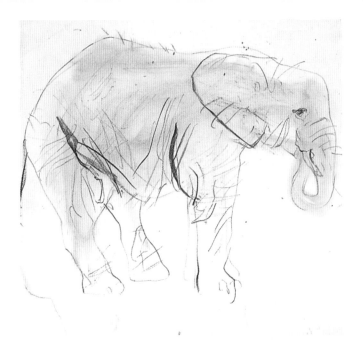

Mixed-media sketches

In Stan Smith's two sketches, the lines are loosely worked in oil pastel (part of the elephant's outline is in pencil), and the washed colour is laid into the pastel spread with turpentine (see page 46). The rapid movements of the pastel strokes show how quickly the sketches were drawn, focusing on the contours and skin texture of the animals' bodies and including only the most essential features.

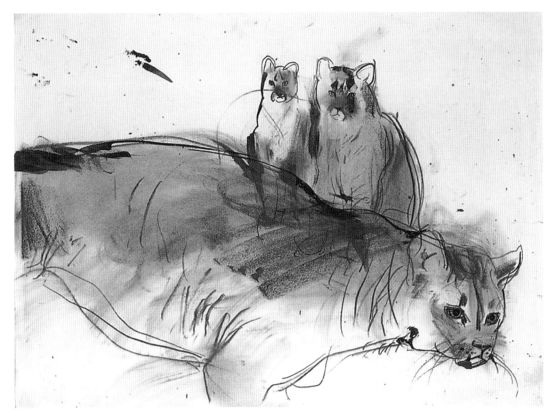

Nature **Animal studies**

A study is a much more detailed rendering than a sketch, typically requiring plenty of time for rigorous visual analysis – focusing on the exact form and texture of the animal. It is, in effect, a portrait, or likeness of the particular animal, whereas a sketch may be more concerned with essential characteristics and the way the creature moves.

Whatever medium you use, you need to build the image patiently with gradual layering of many individual marks. Since you need time to do this, you will almost certainly have to refer to photographs, but ideally, you should combine live observation with photographic reference so that your memory supplements the pictorial record. It is far preferable to take your own photos of a living creature than to work from pictures in books or magazines, and you can also use sketches as reference, taken from the model, a practice that enables you to relate your observations to the technical solutions that your medium can provide.

Pastel on toned paper

The soft grey of the coloured ground in Stephen Paul Plant's *Maine Coon Cat* provides a middle shade from which to key in the brindled markings. The face and features were first drawn in detail, and then the fur texture was developed. A little charcoal was applied as a base for the strong blacks and for finishing touches.

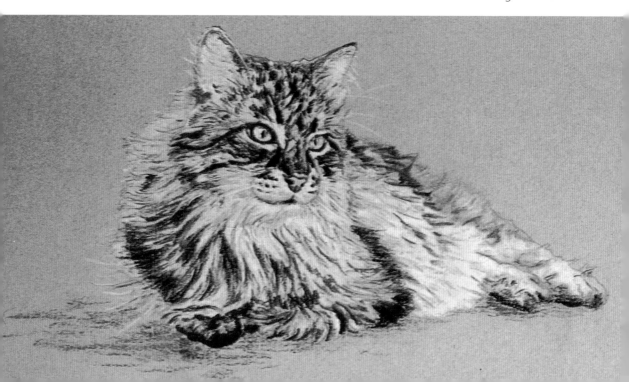

Precise pencil drawing

A soft pencil was used here to record the carefully observed details of a rabbit's head. Individual hairs are represented and used as contour lines to describe the bumps and hollows of the underlying form. This is just one of a sequence of drawings studying the head from all angles.

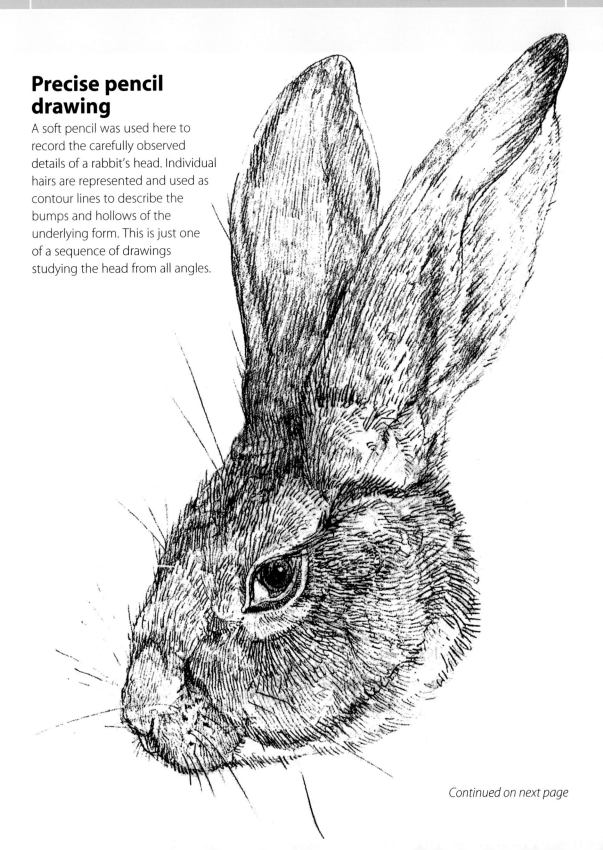

Continued on next page

Surface pattern

This study of a jaguar's head displays a controlled use of pencil shading. An animal with a strongly patterned coat can be difficult to draw, since the form can be dominated by the pattern. The artist here has studied the dark spots carefully, noting how their tonal value changes depending on the light and their position on the form.

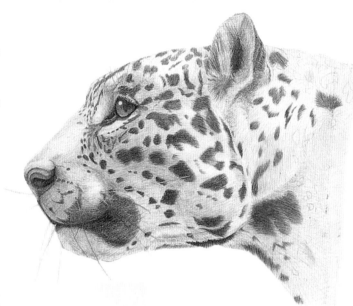

Character

Not all studies are concerned with minute details or with unravelling complex structures. This vigorous charcoal drawing of a gorilla is a study of an animal's individual character. Heavy gestural lines and bold lifting out with an eraser created the massive form. Our attention is focused on the face by the way the gorilla's facial expression has been captured, especially the look in its eyes.

Gathering information

Coloured pencils are an ideal medium for sketches and working drawings that you make while gathering reference material about your subject. Tracy Thompson's sensitive study of an antelope contains detailed information on form, colour and texture, supplemented by the artist's handwritten notes recording special points about the animal's markings. She has used graphite pencil both to sketch the overall contour and to create the sharper linear detail in the fur.

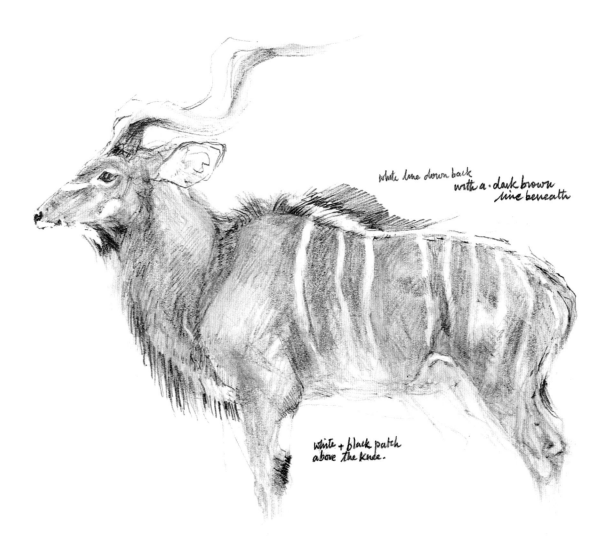

white line down back
with a dark brown
line beneath

white + black patch
above the knee.

Nature **Pattern and texture**

Sometimes it is the overall impression of a particular animal that suggests its suitability as a drawing subject – the grandeur of an elephant or lion, for example – but often it is the variety of patterns, textures and colours that different types of creatures possess that also makes them fascinating subjects for detailed study.

Small-scale creatures such as butterflies, insects and fish that carry intricate, bright-coloured patterns lend themselves particularly well to a delicate medium such as coloured pencils – which allow you to execute fine, linear marks and subtle hatching and shading. In larger creatures, often the colours and markings are more muted and subtle, and may call for a broader approach in soft pastels or oil pastels.

Whatever medium you choose, don't lose sight of the fact that patterns and textures also reflect the underlying forms of the animals. You need to be responsive to small shifts of colour and tone that trace an animal's structure and contour at the same time as describing its surface feel.

Clean colours

Carl Melegari has used soft-textured coloured pencils on smooth, white paper to give the colours a brilliantly clean, jewel-like quality appropriate to the exotic fish. The colours are freely hatched and interwoven, but by varying the weight, thickness and density of the marks, the artist has controlled the modelling of the shapes and the textures and the detail of the patterns on their bodies. The strong directional quality of the line work creates both solid form and atmospheric, watery background.

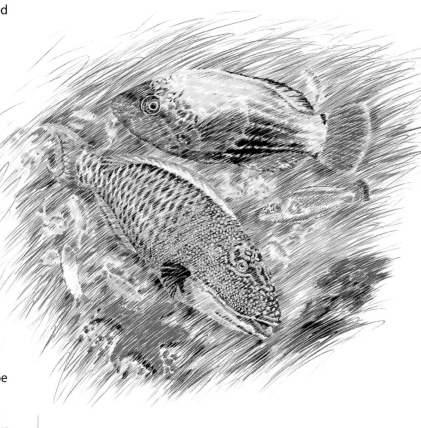

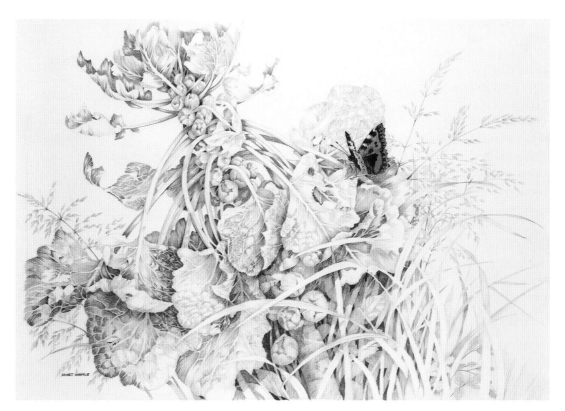

Transforming mundane subjects

A Brussels sprout plant might not be an obvious choice of subject, but Janet Whittle has seen the possibilities for exploiting contrasting shapes and textures to achieve an exciting composition in *A Splash of Colour*. The pencil drawing was completed first, using various grades of pencil, and the butterfly was then added in strong, fairly dry watercolour.

Nature **Animal movement**

There are different ways of conveying a sense of movement in animal or human subjects. One way depends on the composition of the image – you choose a 'snapshot' pose that conveys the essence of a movement sequence, creating a characteristic contour with internal rhythms and tensions. Another way has more to do with technique – you use the marks of your drawing implements very actively to create a network of lines from which the moving form emerges; in this case, the viewer does not necessarily see the whole creature in focus, but still gains an impression of its solid form.

You can produce very interesting drawings by observing a moving animal directly and tracing the lines and shapes that you see on paper. If you prefer a more detailed image, you will need to use photographic references, but be careful not to become stuck in the mode of merely reproducing someone else's image; try to use your skills and imagination to interpret, rather than copy, the picture.

Freezing the action

A racing greyhound is caught extended in mid-air. Yet, even though the action is frozen, this charcoal drawing does not appear static – as many photographs do. A sense of movement is created by the sensitive broken lines and dancing tones that animate the wave-like undulation along the muscular body, skillfully leading the eye from the dog's nose to the tip of its tail. The tail and paws are also slightly blurred as if moving fast.

Studies from life

Shown here is just one of a number of studies created of an impressively agile snow leopard. By capturing the animal in mid-action, the artist has created a sense of movement, because the viewer's imagination naturally supplies details of what might have happened before and after this particular moment. The changing texture of the fur describes the contours of the form, adding to the impression of muscular exertion.

Gestural drawing

The gestures of the artist's hand and arm can be seen from the rhythms of Frank de Brouwer's drawing, giving it a sense of physical movement additional to that implied by the subject. The variations of line – emphatic black coloured pencil over more tentative, shifting graphite pencil marks – enhance the vitality. The non-naturalistic primary colours that provide the medium shades between black and white are also enlivening.

Tutorial **Photographic reference**

To draw an image of this kind from life is obviously impossible. The photograph Judy Martin has used as reference for her pastel drawing was a very dynamic shot, and the incomplete pose, with tail and foreleg cropped, was retained as appropriate to the sense of movement conveyed by the image. The artist had previously studied cheetahs in sketches made at the zoo.

1 The artist is especially interested in the camouflage patterns of animals. The sandy colour of the paper forms the base colour both of the cheetah's fur and the dry, earthy background. The contours are freely sketched in yellow ochre and the highlight areas blocked in with a paler yellow tint.

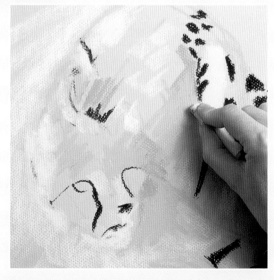

2 Some of the cheetah's markings are drawn in black pastel to key in the darkest tones. Yellow, orange and brown tints within the fur are loosely indicated with rapid shading and broad, short side-strokes.

3 The patches of light and shade surrounding the animal are blocked in, and further tones and colours added to the fur, using gestural marks made with the pastel tip. The hints of colour are overstated at this stage, but will become more integrated with gradual overworking.

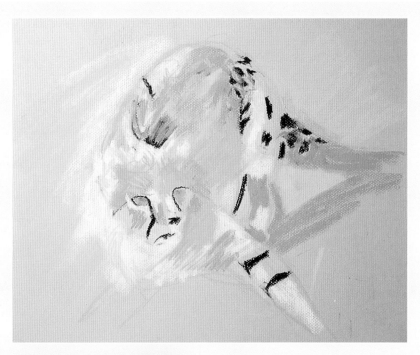

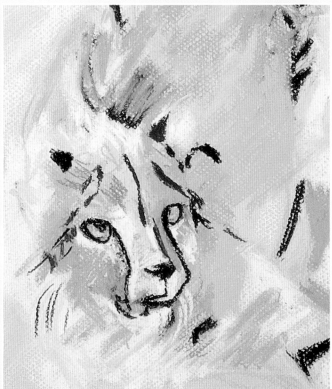

4 The artist begins to define the head, using the natural pattern of black lines around the eyes and nose, and the dark tufts behind the ears. With the stronger blacks in place, the colour detail is reworked more heavily, including the orange and gold eyes.

Continued on next page

5 The pattern of spots on the cheetah's body and ringed markings on the foreleg are thickly worked with the pastel tip. Around the black spots the colour detail is developed with shading around the linear marks, including the white fur highlighting the head and face.

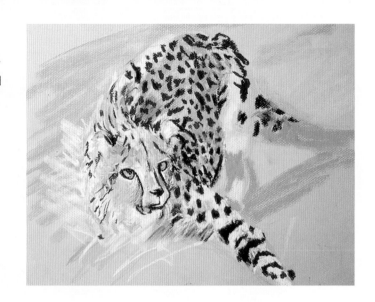

6 The shadow cast under the body and tail is emphasized with a cold grey that contrasts with the warm yellows. The sunlight reflecting on the ground plane is similarly strengthened with the same pale yellow tint previously applied to the fur.

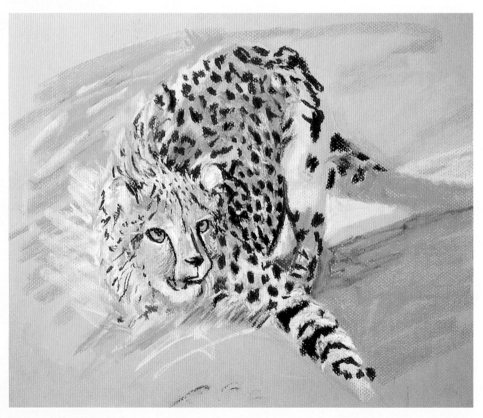

7 The final steps are to put finishing touches to the colour detail. Because the yellows now appear a little flat, stronger orange and red ochre patches are laid into the body and tail, and the spot pattern is reworked in black and sepia. The ruff of fur around the head is more heavily textured.

Judy Martin
Cheetah
Care has been taken not to overwork the drawing by including too much detail, since this would compromise the feeling of movement.

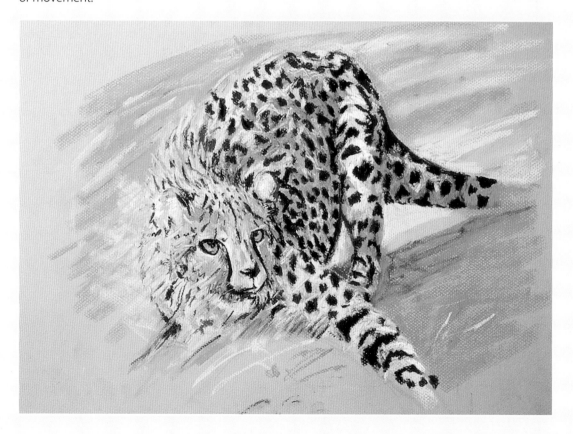

Nature **Flowers and foliage**

Whichever drawing medium you use, flowers provide a vehicle for experimentation with technique, which you can adapt to reveal different impressions of similar subjects, or to investigate the vast natural variety of flower types. You can choose to work with cut flowers, potted plants or garden flowers – according to convenience – and many subjects will be long-lasting enough to provide hours of work from a single selection.

Indoor plants are ideal subject matter, especially since many foliage houseplants are tropical and sub-tropical species with strong, fluid shapes. The colours of variegated leaves also add to the variety of your resources. Outdoor locations – the garden, parks or the open countryside – provide plenty of inspiration. When working outdoors, position yourself close to the subject so you can study the detail; if you wish to bring specimens home to work from, make sure there are no local restrictions on gathering plant material from the wild.

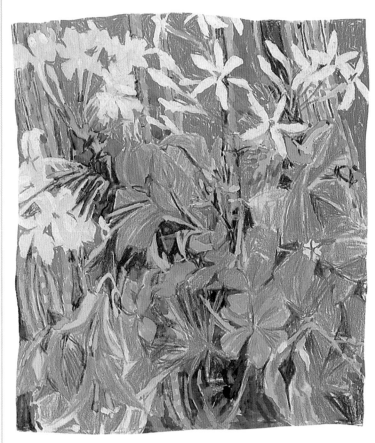

Bold coloured pencil drawing

Thick, grainy pencil colour and a bold approach to forming shapes and patterns in the flowers and fabric background gives Tracy Thompson's *Summer Flowers* a strikingly decorative feel, yet the technique is free and expressive. Touches of opaque watercolour paint intensify colour contrasts. The white flowers are drawn with a brush, so the artist has not had to leave her shapes completely open while applying the pencil colour.

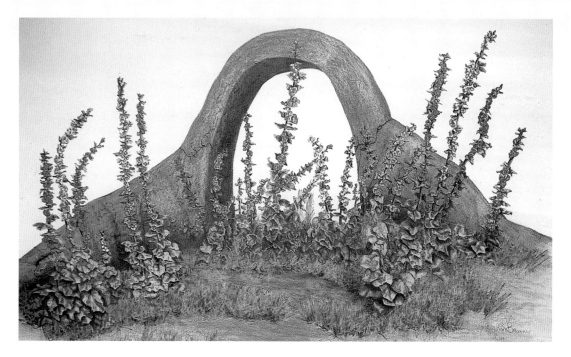

Detailed coloured-pencil drawing

▲ A delicate, painstaking approach to building up form and texture pays off in the attractive detail of Michele Brokaw's *Tao Arch and Hollyhocks*. The artist has cleverly varied the tonal qualities and textures to capture the characteristics of the different flowers and the solid frame of the arch.

Combining methods

▶ Transparent materials are a special challenge to the artist's rendering skills. The combination of shaded and hatched colours and free-line work is well used in Helena Greene's coloured-pencil drawing *Bouquet* to convey the layered effect of the spiky flower forms and stems within the cellophane wrapper.

Continued on next page

Tonal balance

The leaf shapes in Steve Taylor's chosen subject, *Eucalyptus*, are simple forms, and so a controlled tonal balance is essential to the complexity of the rendering. He has used coloured pencil over watercolour, and where veins and stems show white against the colour, the paper is left bare or very lightly painted.

Accurate drawing

The effectiveness of an image with strong graphic qualities like this relies as much on close observation and accurate drawing as on the techniques of applying coloured pencil. In *The Palm Jungle*, close, regular shading has been carefully built up to fill the shapes and make subtle tonal and colour gradations. The grainy texture of the paper allows the applied colours to 'breathe', adding sparkle to the rendering.

Vivid colours

The blazing colours of the orange tulips are a vibrant blend of yellow, orange and red coloured pencils. The more delicate pinks are similarly described with varying tones of the basic hue. The complex arrangement of petals and leaves that forms Angela Morgan's composition has been keyed with a faint pencil outline, and although the overall effect is light and fresh, the pencil colours have been laid in with a confident, free technique.

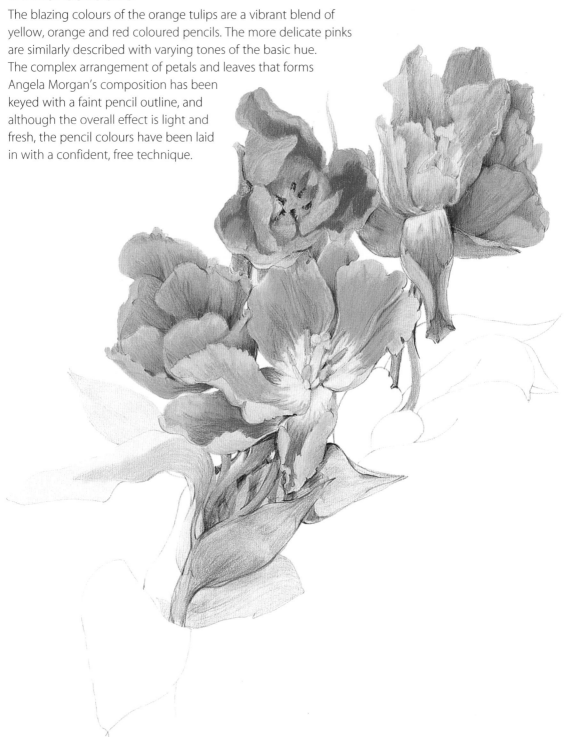

Nature **Container plants**

Plants grown in containers are cultivated for their ornamental qualities, so you should have no trouble in finding an attractive composition, whether from a single specimen or a group of plants. Since the leaves and flowers are growing materials, the shapes and forms are unlikely to change at all within the time you need to complete a drawing.

The background will form an important aspect of your composition, so consider the colours and textures that surround the plant and its container – if necessary, moving the plant or placing something underneath it to provide a sympathetic complement to its form and detail. Natural textures such as wood, cane-work or stone provide interesting surface qualities that do not compete visually with the plant. Alternatively, you could choose to make a colourful, semi-abstract composition by including patterned fabrics and containers that create a busy background.

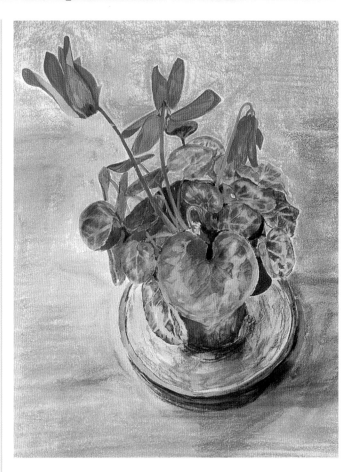

Simple backgrounds

Paint and coloured pencil are a valuable combination for interpreting plants and flowers, giving a wide range of textural qualities that can be matched to aspects of the individual subject. The background in Helena Greene's *Cyclamen* is treated very simply to focus the eye on the detail of the plant.

Unusual compositions

▶ Helena Greene has chosen to crop the container at left and bottom in *Hyacinths* in order to emphasize the upwards sweep of the white flower. She has worked in watercolour and coloured pencil, with the hatched shadings providing distinctive contours and the watercolour washes forming a subtle complement.

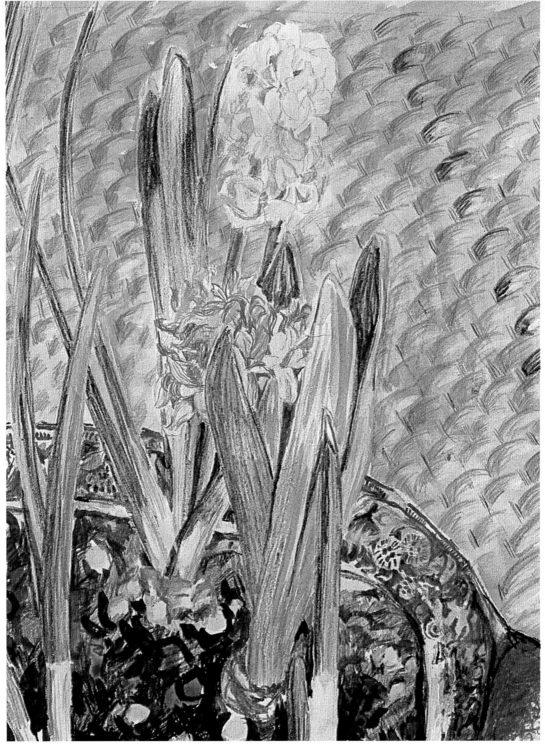

Continued on next page

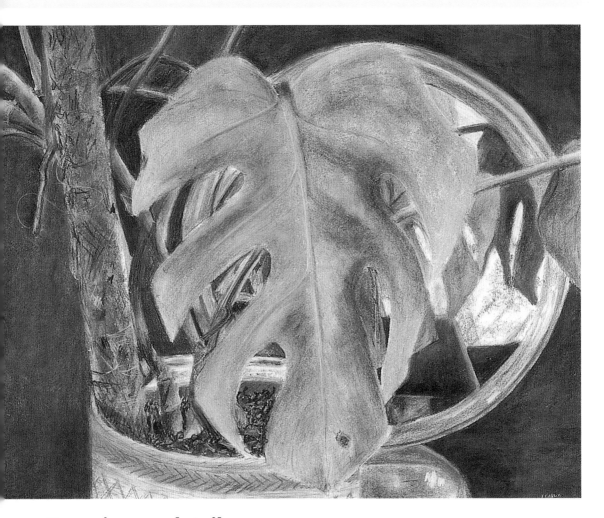

Focusing on details

Potted plants can provide some stimulating compositional
ideas. With a large plant such as this, a single leaf can form
the basis of a drawing, and in this case the circular mirror
behind the leaf adds an unusual and interesting background
of reflections and light. The strong greens were built up with
pastel, rubbed firmly into the paper, with one layer
superimposed over another. Detail has been kept to a
minimum, so that the arrangement of large, simple shapes
is not compromised.

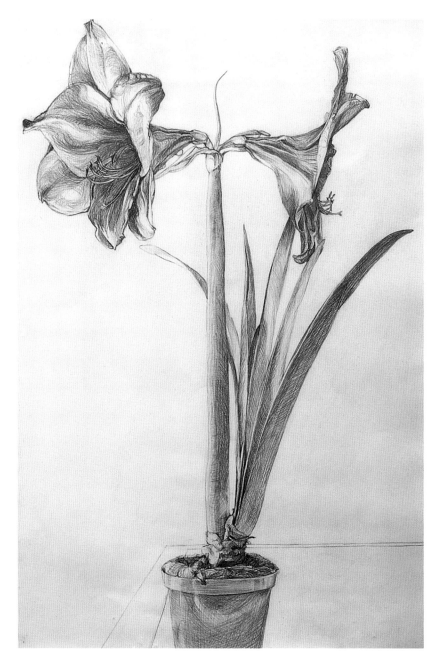

Expressing form and texture

A common difficulty in flower drawing is deciding how to describe the three-dimensional forms of the petals clearly and yet ensure that their unique texture is retained. In this pencil drawing, the artist has differentiated between the textures of the stem, leaves and petals by using different shading techniques and by varying the quality of the line. The stem and leaves are shaded with short cross-hatched strokes, capturing the firmness, while the petals are shaded with longer, curving, much more gentle lines.

Nature **Cut flowers**

Flowers arranged in a vase can make an intriguing subject on their own, or they might constitute an important feature in an interior view or still-life group. If the vase is to be included in the drawing, it is important that it be of a shape and colour that complements the flowers. Sometimes it is possible to find just the right colour and design of vase but, if in doubt, use a plain glass jar, which will be insignificant and yet will allow the stalks of the flowers to be seen.

One of the pitfalls of drawing flowers is that their intrinsic attraction can lead to an obsession with detail. If you are drawing a massed arrangement of flowers, the first things you need to observe are the overall shape, and the relative scale of one flower to another and their position in the defined space. Leave detail until last, because with flowers more than any other subject, it is important to avoid overworking – try to capture the essential characteristic of the subject with a light touch.

Transparent containers

The simple glass jar used to hold this natural arrangement of flowers makes little comment, but it allows the stems to be seen in the water, providing an additional area of interest. The choice of pen and ink as a medium and the linear technique employed allowed the artist to concentrate on the shapes and construction of the flowers. The treatment is economical: the stamens, for example, are simply indicated with a few dots.

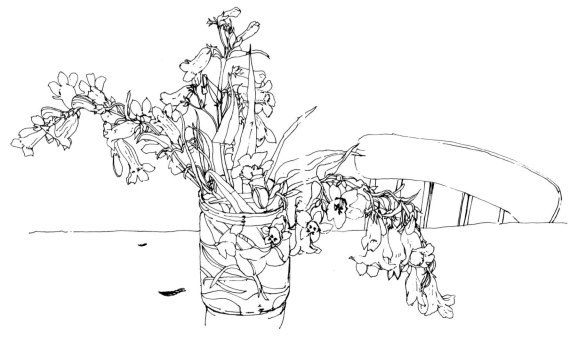

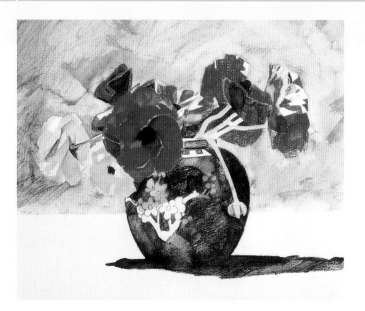

Decorated containers

Here, the artist has chosen a vase with a floral decoration that relates in a positive way to the flowers it contains. Water-soluble pencils on textured watercolour paper have captured the image well. Notice how the stems have been treated as simple white shapes in order to make a link with the decoration on the vase.

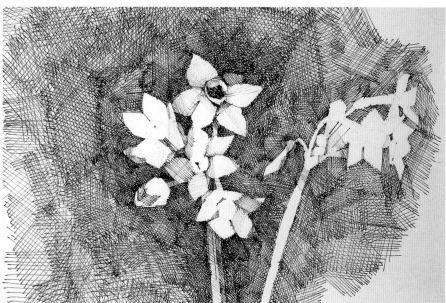

Working in monochrome

To make this drawing, the artist chose a reservoir pen with a medium nib, which produces a line of constant width. Working on white drawing paper, he built up the drawing gradually. Cross-hatching formed the background, with clean white shapes left for the flowers. The shadows of the petals and the flower centre were emphasized, but the flowers were left as light and delicate as possible.

Continued on next page

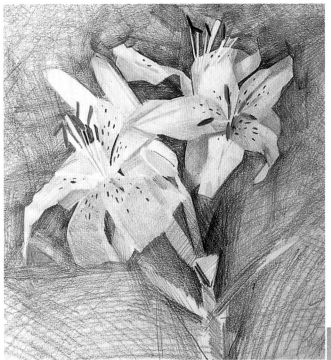

Exercising imagination

In this coloured-pencil drawing, the artist has omitted the container altogether, but our imagination fills it in because we can see that the flowers are standing in something. No more than eight colours were used to produce this vibrant image, with graphite pencils used very effectively for the background (see page 104).

Working with soluble pencils

Soluble watercolour pencils are particularly well suited to flower drawing. They provide a good range of colours that can be used to make linear marks or blended with clean water to create interesting washes. In this example, the outline of the rhododendron was first sketched in with its local colour. The other colours were carefully added with a sable brush and blended with water to develop the drawing.

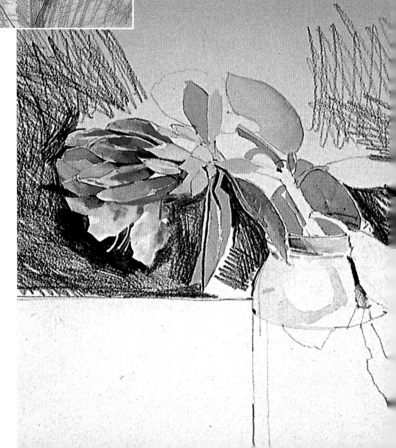

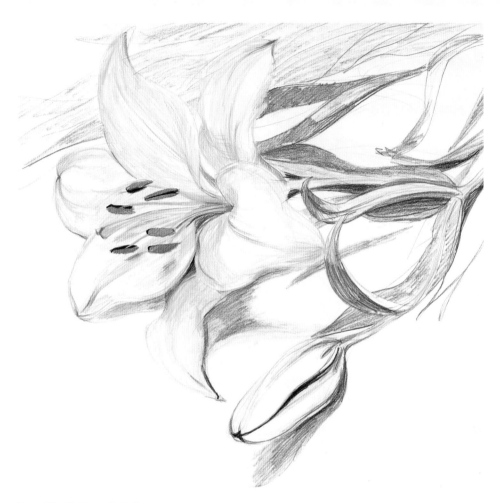

Individual blooms

The artist found this yellow lily among a bunch of mixed flowers, and its perfection seemed to warrant an individual study in coloured pencil. She placed the flower on a white surface, and chose a high viewpoint to make the most of the pattern created by the beautifully coloured petals and ornate anthers, filling the whole of the paper with this close-up detail. The leaves, stems, flower and single bud combine to create an arresting and decorative linear design.

Index

Credits

Demonstration paintings by: Simon Bill, George Cayford, Moira Clinch, Andrew Farmer, Gill Elsbury, Neville Graham, Vana Haggerty, Judy Martin, Marianne Padiña, Ian Ribbons, Stuart Robinson, Ian Simpson, Jane Strother, John Townend, Tracy Thompson and Lawrence Wood.

While every effort has been made to credit contributors, Quarto would like to apologize should there have been any omissions or errors – and would be pleased to make the appropriate correction for future editions of the book.

All other illustrations and photographs are the copyright of Quarto Publishing plc.